Kindly donated in 2018
by Sue Lemasurier,
art student.

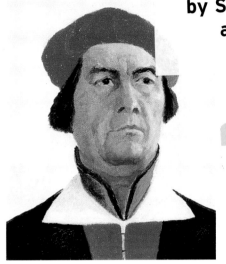

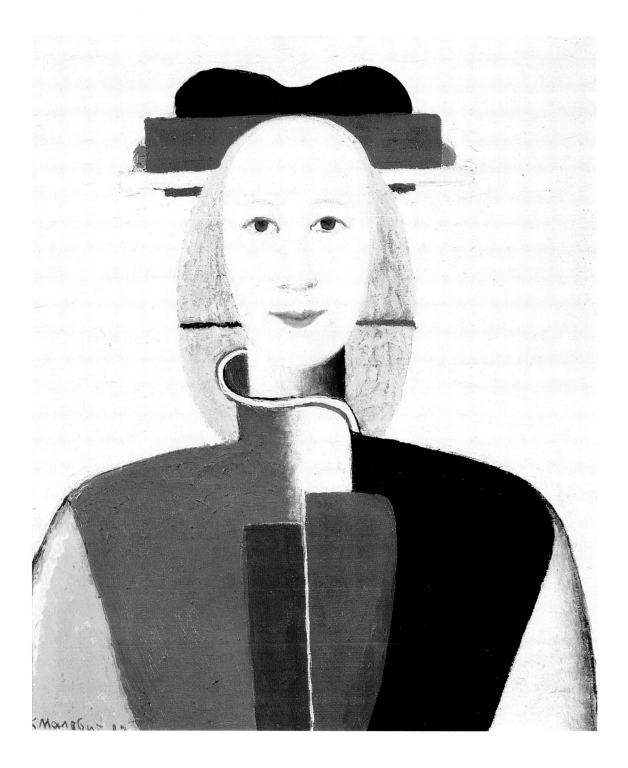

Gilles Néret

KAZIMIR
MALEVICH
1878–1935

and Suprematism

TASCHEN

KÖLN LONDON LOS ANGELES MADRID PARIS TOKYO

ILLUSTRATION PAGE 1:
Self Portrait (detail), 1933
Oil on canvas, 70 x 66 cm
Saint Petersburg, State Russian Museum

ILLUSTRATION PAGE 2:
Girl with Comb in her Hair, 1932–1933
Oil on canvas, 35.5 x 31 cm
Moscow, Tretyakov Gallery

ILLUSTRATION PAGE 4:
Photograph of Malevich with his painting
equipment in Kursk, c. 1900

COVER:
Harvest, Study (detail), c. 1928–1932,
antedated by Malevich to 1909
Oil on plywood, 72.8 x 52.8 cm
Saint Petersburg, State Russian Museum

BACKCOVER:
Self Portrait (detail), 1910–1911
Gouache on paper, 27 x 26.8 cm
Moscow, Tretyakov Gallery.
George Costakis Donation

© 2003 Taschen GmbH
Hohenzollernring 53, D–50 672 Köln
www.taschen.com
© Succession Picasso/VG Bild-Kunst, Bonn 2002 for Picasso
© VG Bild-Kunst, Bonn 2002 for Braque, Matisse and Léger
Text and conception: Gilles Néret
Editorial coordination: Kathrin Murr, Cologne
Translation: Chris Miller, Oxford
Cover: Angelika Taschen, Cologne

Printed in Germany
ISBN 3-8228-1961-X

Contents

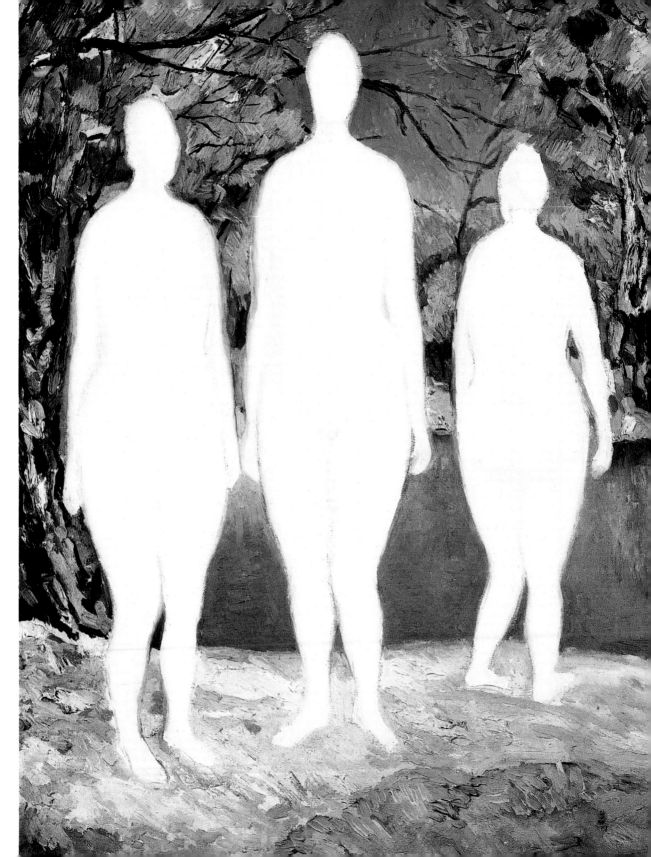

The Seedbeds of Abstraction
1904–1912

"What is modernity?" asked Baudelaire. He was answered by those four pillars of 20th century art: Picasso, who atomised form, Matisse, who emancipated colour, Duchamp, who abolished the artwork in his "ready-mades", and Malevich, who brandished his iconic *Black Square* like a crucifix. Each might have adopted Picasso's 1923 dictum: "In art, we express what nature is not". Malevich said something similar in relation to his *Black Square*: "Comrades, arise, free yourselves from the tyranny of objects".

Malevich added a further dimension to the programmes of his three great peers. The *Black Square* was not merely a symbol of liberty, it was also an icon, made not to be adored but to lead the spectator into the embrace of the divine. Nor can his *œuvre* be understood without reference to his mysticism – which was anathema to the Stalinist regime under which he lived. He was forced to cover his own tracks in self-protection. The confusions thus generated have combined with the hazards of Soviet history and historiography to make him into a mythical figure. He died in 1935, and, as Serge Fauchereau notes, was written out of Soviet art history for the next twenty-five years. But censorship did nothing to diminish his status. The *Black Square* became a landmark, a rallying-point, and a symbol. In the hands of the incompetent, it also became an excuse.

Malevich's corpus includes pictorial, architectural, and theoretical strands. It is central to the most important creative trends of the 20th century, and its emphasis on "the pictorial as such" remains an inspiration to artists everywhere. Yet his work has, till now, been presented in obscure and incomplete fashion; only recently has the chronology of his work been elucidated. This achievement is largely to the credit of Jean-Claude Marcadé, Malevich's French translator and one of the few specialists in the Russian avant-garde able to explicate his *œuvre*. Malevich was, Marcadé tells us, a *samorodok* (literally "a nugget of mineral", metaphorically "an outcrop of genius"): "Nothing about the milieu into which the *samorodok* is born suggests that he will ever amount to anything. Unlike the autodidact, who cannot transcend his random education, the *samorodok* reaches levels of achievement unattainable to virtue, hard work, intelligence, wealth or academic prowess. Malevich is a model *samorodok,* and at poles from the intellectual type figured, for example, in Kandinsky."

Though deeply enrooted in Russian culture, Malevich, like his companion in genius, Dostoyevsky, was of Polish parentage. But his birthright – he was born in Kiev in 1878 – was the Ukraine, and when he spoke of his background, he always emphasised this. Occasionally, out of tact or mischief, he would lay claim to Polishness, sometimes writing the Polish (Latin alphabet) version of his name: Kazimierz Malewicz. He left two incomplete autobiographical sketches, which

Pysanki (Ukrainian coloured eggs), from top:
1. Kostmach village, Ivano-Frankovsk region, 1911
Lvov, Lvov Ethnographic Museum
2. Kiev region, 1911
Kiev, Ukraine National Museum of Decorative Arts

ILLUSTRATION PAGE 6:
Women Bathers, c. 1930, antedated to 1908
Oil on canvas, 59 x 48 cm
Saint Petersburg, State Russian Museum

Washing on the Line, 1902–1903
Oil on canvas, 21.2 x 27.7 cm
Athens, Costakis Collection

Claude Monet: *Rouen Cathedral, Sunset*, 1894
Oil on canvas, 99.5 x 65.5 cm
Boston, Museum of Fine Arts

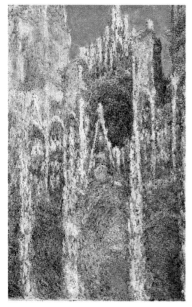

PAGE 9:
Church, c. 1905
Oil on cardboard, 60.3 x 44 cm
Athens, Costakis Collection

further narrow his allegiances. Between the world of the worker, exemplified in the sugar-beet factory where his father was employed, and that of the peasant, with its local costumes set against the "art-colours" of the Ukrainian landscape, his choice was made. His was the soul of a peasant. Unsurprisingly, when Futurism sought to consecrate the machine, Malevich would have none of it.

On the one hand, there was the hideous sugar-refinery. "There, every worker focused intently on the working of the machine as if on the movements of a predatory animal. And, at the same time, you had to keep a watchful eye on your own movements. One wrong move meant death or mutilation. For the small boy that I was, these machines seemed man-eating beasts." On the other, there was the peasant world, in which he felt entirely at home, and whose praises he sang throughout his life, contrasting it with that of the machine. "I always envied smallholders, whose lives seemed to me one of complete liberty, lived out in nature: pasturing their horses, sleeping under the heavens, guarding great herds of pigs that they would drive back at nightfall sitting astride a pig and holding onto its ears…". For Malevich, the peasants were humanity itself, and he loved them. (In his late works he depicted them as mutilated puppets in protest at the ruthless collectivisation campaign.) To the peasantry he owed his first encounters with drawing and painting: "One essential distinction between workers and peasants: drawing. Workers never drew and were neither capable of decorating their houses nor concerned with art – in contrast with the peasants, who all were. Country people were interested in art (a word I did not then know). To put it more precisely, they made objects that I loved. In these objects lay the secret of my sympathy for them. I was very moved to see peasants making ornaments, and I would help them to seal the floor of their *khata* with clay or make drawings on the stove. They were remarkably good at representing cocks, little horses and flowers. The colours were prepared on the spot using various kinds of clay and Antwerp blue." Coloured eggs (*pysanki*, p. 7), with their symbolic, geometrical decoration, also formed part of the Ukraine's living tradition, ornamenting the table at Easter. They remained present in Malevich's mind throughout his career.

Oak and Dryads, c. 1908
Watercolour and gouache on paper, 21 x 28 cm
N. Manoukian Collection

The national poet, Taras Shevchenko (1814–1861), describing the glittering rural landscapes that first inspired Malevich to paint, says "In our Ukraine, every village is trim as a painted egg". To this we should add the place enjoyed by the icon in religious life and in the Orthodox world as a whole; with this Malevich was, though Catholic by parentage, intimately acquainted. These were the influences fermenting in the adolescent Malevich, and they prepared him to choose neither factory nor field, but something quite different: painting.

His goal was Moscow. There, he had heard, a new form of painting was being practised. To attain his end, he took employment for a while with the technical services of the Kursk-Moscow railway. "In this way not months but years went by, until I had saved a little money…". We know little about this period. Malevich tells us that he was influenced by the "Wanderers", the Russian Naturalist painters, Repin and Shishkin, and their Ukrainian rival Nikolai Pimonenko; that he exhibited with other amateurs and sold a few works; that he painted in the

countryside with his friend Lev Kvachevski. But none of the works painted from nature in "Wanderer" style has ever turned up. We do know that by 1904, Malevich was in Moscow. There he experienced a veritable revelation, the "great event" as he calls it. It was the discovery of Monet's *Rouen Cathedral* paintings, with their little strokes of pure colour. He saw them in the celebrated collection of Shchukin, a wealthy patron of the arts, who, like that other famous collector Morozov, was happy to show his acquisitions to the budding Russian avant-garde of the turn of the 20th century. "For the first time, I saw the luminous reflections of a blue sky, painted in pure and limpid tones. Thereafter, I set about painting luminous pictures, full of happiness and sun… At this point, I became an Impressionist." Few acknowledged works have survived from this period, and Marcadé's listing of them is based on the canvases that Malevich took with him in 1927 for his Warsaw and Berlin retrospective. Paintings Malevich deemed worthy of representing his first, Impressionist style include *Washing on the Line*

AT THE TOP, LEFT: *Relaxing, Society in Top Hats*, 1908
Water colour, gouache, Indian ink and white lead on cardboard, 23.8 x 30.2 cm
Saint Petersburg, State Russian Museum

AT THE TOP, RIGHT: Photograph of Malevich, c. 1906

LEFT: *Two Dryads*, c. 1908
Ink vignette, 19.7 x 13.5 cm
Former Leporskaya Collection

RIGHT: *Epitaphios (The Shroud of Christ, Plashchanista)*, 1908
Gouache on cardboard, 23.4 x 34.3 cm
Moscow, Tretyakov Gallery. Georges Costakis Donation

(p. 8) and *Church* (p. 9). The aesthetic of both is in direct line of descent from *Rouen Cathedral*, which they also resemble structurally. In his Vitebsk brochure, *On New Systems in Art. Static and Speed* (1919), Malevich explains the radical new notions implanted by the spectacle of the Monets: "Nobody saw the painting itself, no one saw the movement of the touches of colour, no one saw them growing unchecked, indefinitely. For most people, Monet had, when painting the cathedral, sought to render the light and the shadows on the walls. But they were wrong. In fact, all Monet's efforts had gone into the walls of the cathedral. His main task was not the shadows and the light, but the painting that lay in the shadow and the light… we must focus on what is pictorial, and not on the samovar, the cathedral, the gourd or the Gioconda. And when the artist paints, and he plants the paint, and the object is his flower-bed, he must sow the paint in such a way that the object disappears, because it is merely a ground for the visible paint with which it is painted… Important clues for the latest movements in pictorial art have been given, by Cézanne to Cubism and by Van Gogh to Futurism".

And by sewing Monet's little strokes of colour, Malevich went on to grow his own black, red and variegated squares. The subject was to become a pretext, a ritual: emblematic but never circumstantial. In *Light and Colour* (1922–25), he put it like this: "Something that people called light has become as impermeable as any material". This is in harmony with Mallarmé's maxim: "To name an object is to eliminate three-quarters of the pleasure afforded by the poem: our dream is to suggest it."

Impressionism was so important a point of departure for Malevich's abstraction that twenty years later he returned to it, now incorporating the lessons of the black square. These were Impressionist pictures revised and corrected by his subsequent invention, Suprematism, and he antedated them to the very early 20th century. In this way, he thoroughly bewildered the art commissars of Soviet Russia (and set today's museum curators all kinds of puzzles), countering the brute force of Stalin's enforcers with his own anarchic humour. In the interim, the Cyrillic alphabet had been simplified, losing several letters to the decree of 23 December 1917. The false dates that he inserted were all well before 1917, but he deliberately inscribed them in reformed Cyrillic, as though thumbing his nose at the ignorance of his critics. According to Marcadé, who first reordered the paintings chronologically, "the antedated canvases form a set of paintings of which revised old canvases in all probability form one part, and new works painted in Neo-Impressionist style another." For Stalin's Soviet Union had sadly preceded Hitler's Germany in denouncing the newest art, condemning not merely living creators but, in the Impressionists, the dead too, all in the name of the Socialist Realism first proclaimed in 1934. As early as 1919, in his *New Systems in Art*, Malevich was complaining that the Socialist leaders were attacking the "degenerates of art", a formula soon to be adopted in Berlin. "People are always demanding that art be comprehensible and never make the effort to adapt their own minds to comprehend it; the most cultivated socialists have taken this path, and require of art what a shopkeeper requires of the sign-painter, that he represent the goods for sale in the shop as accurately as possible". To take just one example, *Bathers* (p. 6) was exhibited in Amsterdam's Stedelijk Museum during the 1989 retrospective of Malevich's work. There its date was given as 1908, when in fact, Marcadé says, it was painted around 1930, as is perfectly clear from the three ghostly nudes it portrays; they are self-evidently closer to a Suprematist white square than to a self-respecting Impressionist painting of the turn of the 20th century.

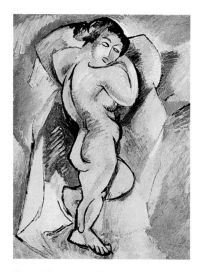

Georges Braque: *Large Nude*, 1907–1908
Oil on canvas, 142 x 102 cm
Private collection

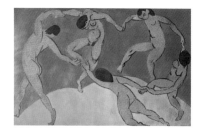

Henri Matisse: *Dance*, 1910
Oil on canvas, 260 x 391 cm
Saint Petersburg, Hermitage Museum

PAGE 12:
Bather, 1911
Gouache on paper, 105 x 69 cm
Amsterdam, Stedelijk Museum

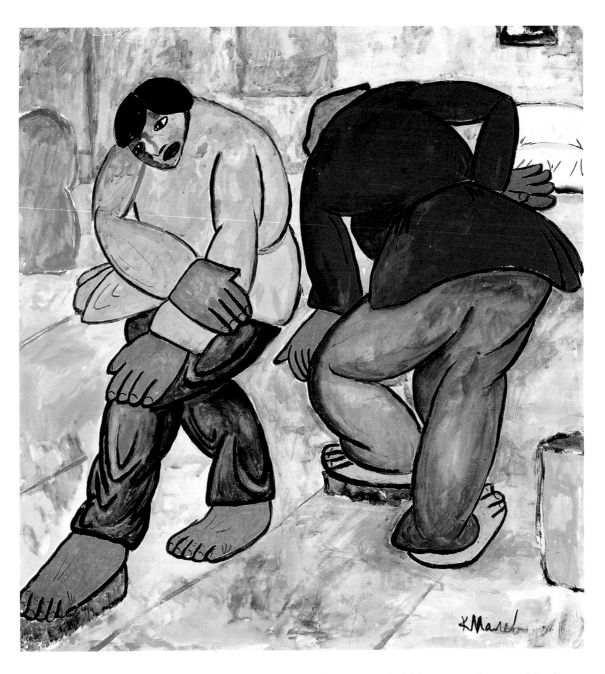

Floor Polishers, 1911–1912
Gouache on paper, 77.7 x 71 cm
Amsterdam, Stedelijk Museum

PAGE 15:
Argentine Polka, 1911
Gouache, 104 x 68.5 cm
J. J. Aberbach Collection

Having been awoken by Monet, Malevich began to explore everything that France had sent to Moscow. He omitted nothing and failed in nothing. With works like *Dogs and Dryads* (p. 10) or *Relaxing, Society in Top Hats* (p. 11, both 1908), he showed himself an accomplished Symbolist in whom neither the Mannerism nor the erotic touch integral to that style are missing. Verhaeren and Maeterlinck were both well known in Russia, and Redon in particular, having drawn the cover of the magazine *The Scales* in 1904, was, in Moscow, a veritable star. *Christ's Shroud* and *Two Dryads* (p. 11) perfectly echo Redon's

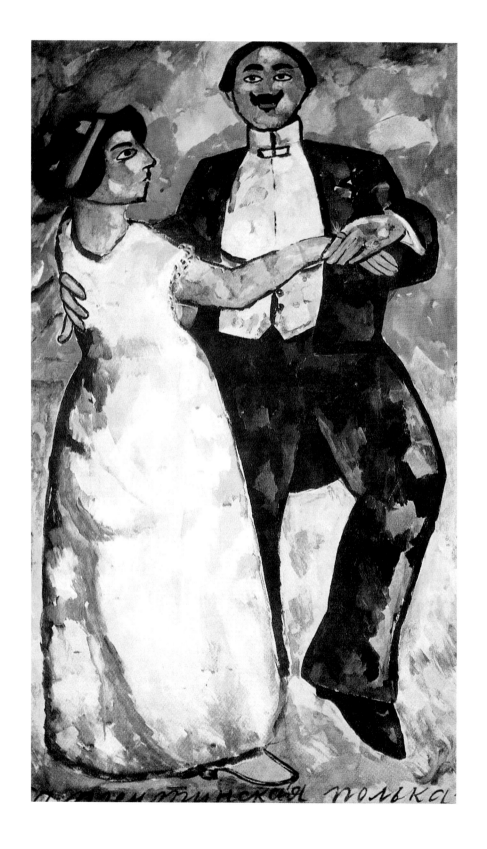

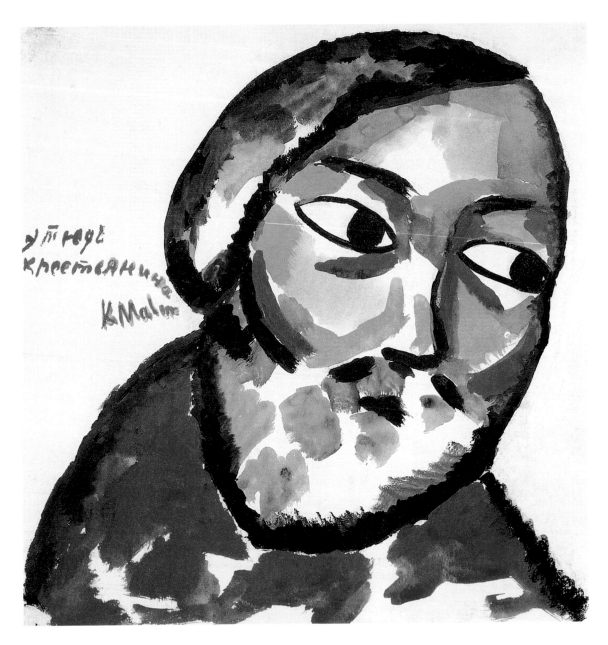

Study of a Peasant, c. 1911–1912
Gouache on paper, 26.7 x 32 cm
Paris, Musée national d'Art moderne –
Centre Georges Pompidou
The work formerly belonged to Kandinsky,
who showed it at the *Blaue Reiter* exhibition
in Berlin, 1912.

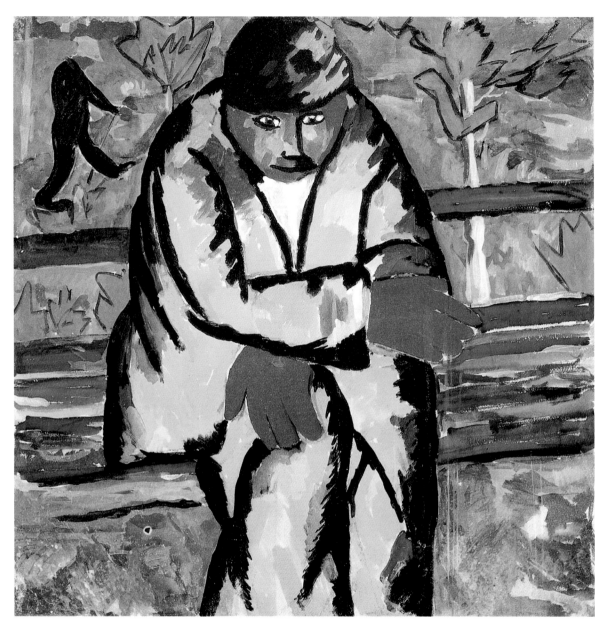

On the Boulevard, c. 1911
Gouache on paper, 72 x 71 cm
Amsterdam, Stedelijk Museum

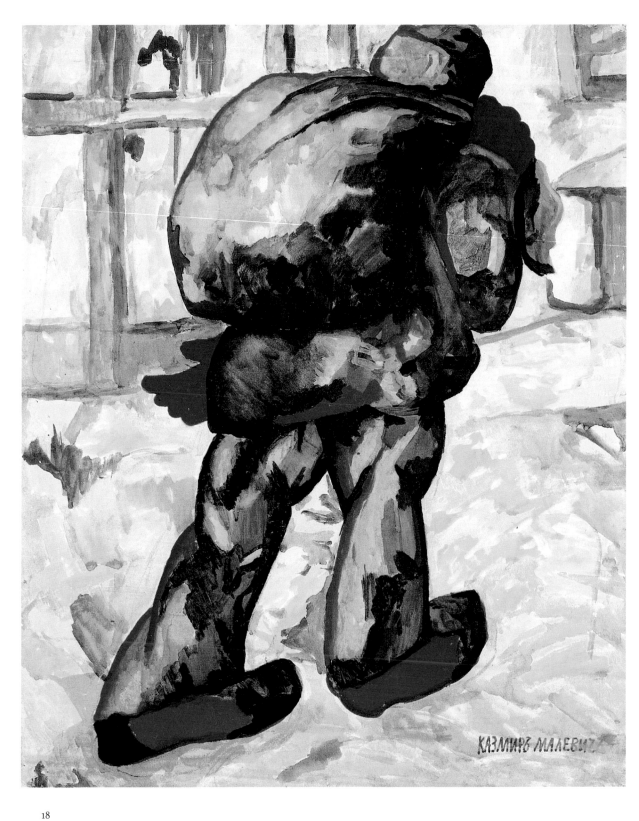

КАЗМИРЪ МАЛЕВИЧ

vignettes and *culs-de-lampe* for *The Scales*: we see the same haloed heads, the same plant motifs, and the same protagonist laid out in his tomb. But, as Fauchereau observes, "… over and above the fin-de-siècle imagery, the work tends toward naïve medieval art; Malevich often expressed his admiration for popular art and icon-painting". Malevich later made efforts to conceal this outbreak of Symbolist fever; he brought no such works to his 1927 retrospect in the West, nor did he mention them in his writings. Their crime was that they did not advance the development of art; they were "figurative lumber", "otiose illusionism".

Malevich had other and better things to be doing. His object was to discover a new form of expression by pitting against the treasures of Western art in the Morozov and Shchukin collections every fibre of his Russian soul. The scene of this confrontation was the *Golden Fleece* Salon of 1908. France and Russia had never had such close artistic links. The arts were in ferment, with the French inclining toward the decadent, the Russians to the primitive. The *Golden Fleece* Salon was to bring together some three hundred paintings, two hundred of them from Paris, juxtaposing the French and Russian artistic scenes. For the Russian avant-garde, Larionov and Goncharova were the figureheads; they were more aesthetically "advanced" than Malevich. The French fielded an exceptional team: Cézanne, Gauguin, Renoir, Degas and Pissarro were all present, with adoptive Frenchman Van Gogh, Nabis such as Denis, Bonnard, Vuillard and Sérusier, and Pointillistes like Signac. But the principal attraction, the one best-suited to the Russian mood of the time, was the Fauves: Matisse, Derain, Marquet, and Van Dongen. Cézannism and Fauvism were revealed as entirely complementary to Russian Primitivism. Noting Russian enthusiasm, Sarabandiov says that they "used the discoveries of Cézanne, and sometimes of Matisse and certain other French painters, to restore to the object all its mass, volumes, colour and three-dimensionality, aspiring to a synthesis of colour and form". As if in a joyous, fraternal party, the marriage of popular Slavic art with Cézannian, Fauve and Pre-Cubist tendencies was celebrated. The new Russian art, of which Malevich was now an eminent exponent, combined several pictorial cultures with popular (non-academic) Slavic art. Marcadé again: "One must never lose sight of the fact that most of the great Russian avant-garde painters (Larionov, Goncharova, Chagall, Malevich, and Filonov) shared this iconographical starting point. They did not integrate primitive elements into a new conception of the surface of the painting, as the French integrated African and Polynesian art into a Cézannian structure. They incorporated the formal discoveries of Post-Impressionism into an essentially Primitivist structure."

The gouache *Bather* (p. 12) is a shining example of this synthesis. It shows a direct line of descent from Braque's *Large Nude* (p. 13: seen in Moscow at the *Golden Fleece* exhibition in 1909 under the title *Bather*) and above all Matisse's *Dance* (p. 13). But under Malevich's Ukraine-inspired brush, the *Bather* became a hefty red devil executing a savage dance miles from the grace and angelism of Matisse's *Dance*. The entire series of gouaches from 1910–11, with their bright, pure pigments, reflect Matisse's gift to the Russian avant-gardist, notably *Floor-Polishers* (p. 14) and *Argentine Polka* (p. 15). Both in their way depict dances, the one as wild as the other is measured. Marcadé observes "The dance movement (a pictorial dance) is still frozen in Braque's *Large Nude*. It becomes a zigzag in Picasso's *Dance of the Veils*, then develops into the harmonious arabesque rhythms of Matisse's *Dance*. In the Neo-Primitivist Malevich, there is an oscillation between its hieratic nature and the implication of movement. *Argentine*

Washerwoman, c. 1911–1912
Pencil on paper, 9 x 10 cm
Cologne, Museum Ludwig

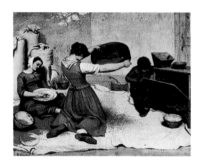

Gustave Courbet: *Grain Sifters* (detail), 1855
Oil on canvas, 131 x 167 cm
Nantes, Musée des Beaux Arts

PAGE 18:
Man with a Sack, c. 1911–1912
Gouache on paper, 88 x 71 cm
Amsterdam, Stedelijk Museum
Signed in cursive Cyrillic capitals
"Kazmir Malevich"

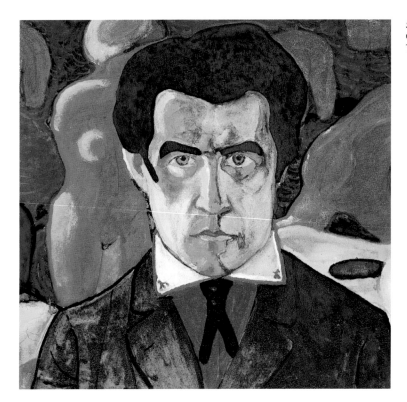

Self Portrait, 1910–1911
Gouache on paper, 27 x 26.8 cm. Moscow,
Tretyakov Gallery. George Costakis Donation

Polka transforms the dancing couple into ancient idols caught in gestures of the most commonplace kind."

Paris was not the only source for Russian Neo-Primitivism. It took inspiration from traditional handcrafts, primitive sculpture (p. 22), embroidery, tapestries (p. 28), pastry-moulds, ceramic tiles, and profane and religious imagery. All this provided a vast range of expression and humour, along with an emphasis on the so-called "provincial-trivial". In principle, Gauguin was the French influence underpinning the theories of the Russian avant-garde. Later, Malevich came to prefer Cézanne, but in 1915 he wrote: "Gauguin, who fled culture and took refuge with savages, found a greater freedom among these primitives that had been offered by academicism. He was driven to flight by intuitive reason. He was looking for something simple, curved and crude. He was in quest of the will to create. He wanted at all costs to avoid painting as the commonsense eye sees."

But Malevich was developing rapidly. For a time, he had, as we have said, felt very close to Goncharova, but as Marcelin Pleynet notes, "For Goncharova, forms were an end in themselves, whereas for Malevich they were already only a means to an end". Goncharova continued loyal to Gauguin while Malevich was already electing Cézanne for his own inspiration. This he explained in *From Cézanne to Suprematism* (1920): "We observe in art an inspiration towards the primitive, toward the simplification of the visible, and we call this movement *primitivism*, even when it occurs in our contemporary world. Many people attribute to Gauguin the original primitivist impetus, but this is wrong… The primitive character apparent in many contemporary painters is the aspiration to reduce forms to a geometrical body, that it is, toward the geometrisation of form that Cézanne called for; this is what he suggested by reducing nature to the

Paul Cézanne: *Card Players*, 1890–1892
Oil on canvas, 64.7 x 81.2 cm
New York, The Metropolitan Museum of Art

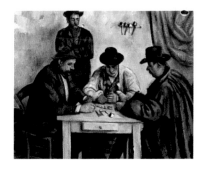

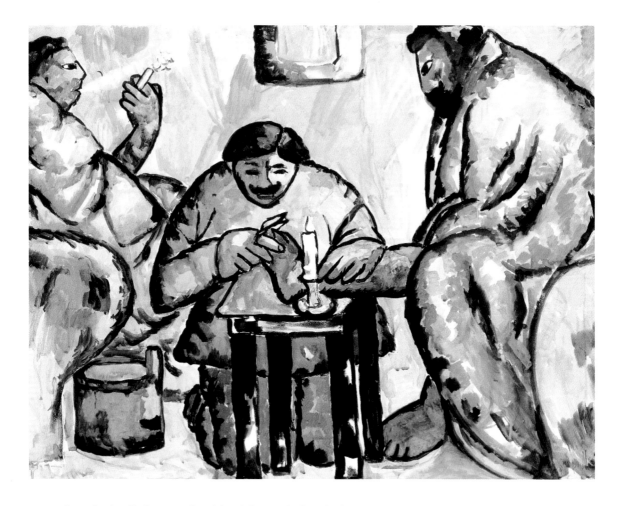

cone, cube and sphere". Thus in Malevich heads became balls with glinting eyes; bodies become sugar-loaves, like the seated figure in *On the Boulevard* (p. 17) who occupies almost the entire space of the painting. Similarly, the face in *Study of a Peasant* (p. 16) resembles a mask. We can identify originals for the curved backs in a series of paintings: *Washerwoman* derives from Courbet's *Grain Sifters* (p. 19), and *Peasant Woman with Buckets and Child* (p. 23) is inspired by Van Gogh, who had himself taken his motif from Millet's celebrated *Gleaners*. But for Malevich curved backs such as that of *Man Carrying a Sack* (p. 11) are merely the immemorial emblem of toiling peasants bending to tend the earth. The particularity of his own Neo-Primitivist treatment was, as so often, its consecration of the labourer's pose. Here he was assisted as much by the icon tradition as by peasant art.

In his autobiographical writings, Malevich established a connection between the colours of the peasant world and the beauty of icons. "I perceived a link between peasant art and that of the icon: the art of the icon is the superior form of peasant art. I discovered in icons the entire spiritual side of the *peasant epoch*. I understood the peasants through the icons. I perceived… [the icons'] faces, not as those of saints, but as those of simple men… Knowledge of the icon had convinced me that the main thing was not to learn anatomy and perspective,

Kammennaya Baba (Woman in Stone)
Primitive Turco-Mongol sculpture

nor to render nature in all its truth, but to gain an intuition of the nature of art and artistic realism." Thus the *Peasant Women in Church* (p. 22) are all icons, with flat, oval faces and large eyes, like those of masks. In 1907-8, Picasso too was painting faces stylised in the manner of African masks, notably in *Three Women* (p. 22). But Malevich's "masks" exhibit a tenderness wholly lacking in Picasso's.

The large gouache *Chiropodist* (p. 21) concluded 1912 with a homage rendered to Cézanne by his Russian disciple. Malevich was clearly inspired by Cézanne's *Card Players*, which he may have seen reproduced in the magazine *Apollo* in 1910. Triangular construction and rigorous symmetry are common to both. In *From Cézanne to Suprematism*, Malevich declared that "Cézanne actuated a new technique of the picture surface as such, deducing his pictorial technique from the state in which Impressionism had left it; by his use of form, he imparted a sense of the tendency of forms toward contrast." That same year, analysing *Card Players* for his students, he expressed himself more clearly: "This picture shows four figures, who strike us as giants dressed in very heavy fabrics. The table at which three of the giants are seated represents something really very small, which might have occupied three times the space had the man in coat or jacket stood up… Thus spatial elements are lacking in this work because of the interweaving of the spatial differences coloured by the overhead perspective. The consequence is that this work gives an impression of flatness, on the flat surface of which all the objects are given an identical pictorial realisation. The power of this realisation is such that it is not spatially clothed in gradations of light such as we see in the Impressionists". He might almost have been analysing the Suprematist spatial compositions he had yet to paint.

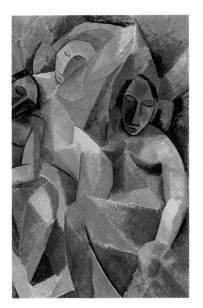

Pablo Picasso: *Three Women* (detail), 1908
Oil on canvas, 200 x 185 cm
Saint Petersburg, Hermitage Museum

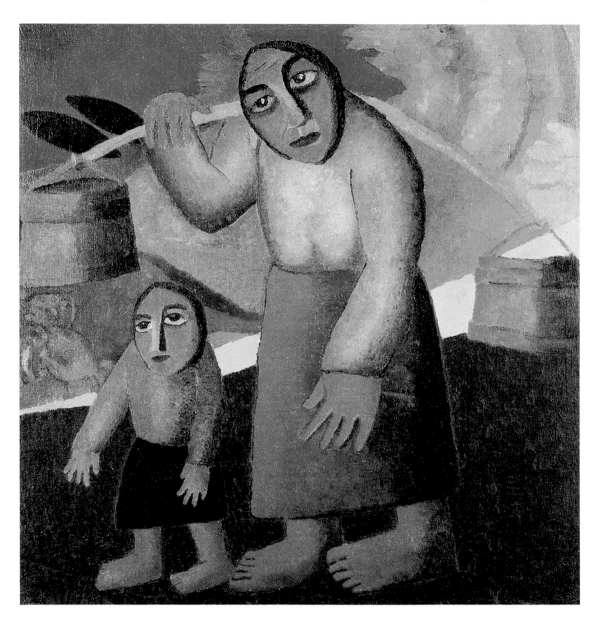

Peasant Woman with Buckets and Child, c. 1912
Oil on canvas, 73 x 73 cm
Amsterdam, Stedelijk Museum

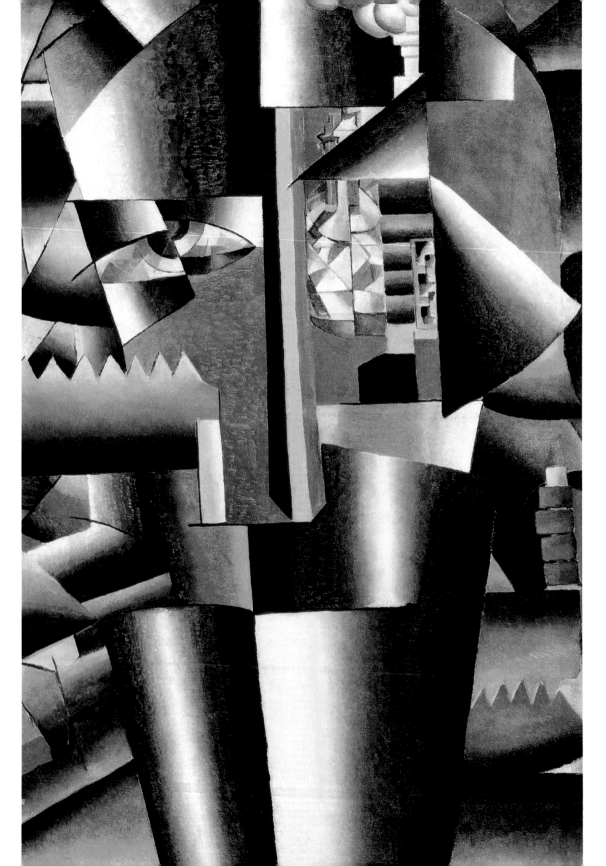

The All-Seeing Eye
1912–1914

In 1912–13 Moscow, revolt was the order of the day. The Russian avant-garde was up in arms against the invader, be he Fauve, Cubist, Futurist, or some emissary of Die Brücke or Der Blaue Reiter. "Only after it has taken the measure of its oriental resources and acknowledged itself Asian will Russian art enter a new phase and reject the shameful and absurd yoke of Europe – Europe that we have long since overtaken." Thus Benedikt Livshits in his *Archer with One and a Half Eyes*. Larionov joined the chorus: "We are against the West, which vulgarizes our oriental forms…" Larionov founded Rayonism, a future-oriented movement in which he was joined by Goncharova, Shevchenko, Le Dantu and other painters, partly in order to distinguish himself from the Italian Futurist movement. When Marinetti visited Russia, in early 1914, Larionov and Khlebnikov showed themselves extremely hostile, and dubbed themselves Avenirists or Cubo-Futurists in order to repudiate any association with Marinetti.

Malevich, on the other hand, had no nationalist agenda. He was too conscious of the Asiatic culture within him to fear European influences. On the contrary, he was determined that he should have a share in any influences going, for his goal was to create a "universal art" while retaining his Russian roots. He had left Neo-Primitivism far behind him, and his relations with Larionov suffered in consequence. Rayonism held little interest for him. At the *Target* exhibition of Spring 1913, Malevich's presentation of works influenced by Cubism stood out among the Neo-Primitivist and Rayonist offerings. He was already taking flight for new horizons, and was about to become the leader of a new Russian avant-garde. He was not, however, isolated; he had grown close to the Futurists who met at Saint-Petersburg in the houses of Matyushin and Elena Guro. The poets Alexis Khruchenyk and Velimir Khlebnikov and the painter Olga Rozanova were among the most active of this group. With their Moscow-based counterparts, Vladimir Mayakovsky, the Burlyuk brothers and Vasily Kamensky, they formed a rich and varied Futurist movement. Their uncompromising manifesto, *A Slap at Public Taste,* signed by David Burlyuk, Khruchenyk, Mayakovsky and Khlebnikov, enjoyed a *succès de scandale*: "We alone are the true visage of our Time… The Past is cramping. The Academy and Pushkin are more incomprehensible than hieroglyphs!"

By dint of applying Cézanne's principle – geometrisation – in very literal fashion, Malevich found his geometrical analyses increasingly abstract in ten-

Perfected Portrait of Ivan Vasilievich Klyun,
1913
Lithograph, 14.9 x 10.5 cm
Inserted between pages 2 and 3 of Khruchenyk's book, *The Piglets*

AT THE TOP:
Eye (detail), 1913
Sketch for the *Perfected Portrait of Ivan Vasilievich Klyun*, 20.5 x 17 cm
Former A. Leporskaya Collection

PAGE 24:
Perfected Portrait of Ivan Vasilievich Klyun,
1913
Oil on canvas, 112 x 70 cm
Saint Petersburg, State Russian Museum

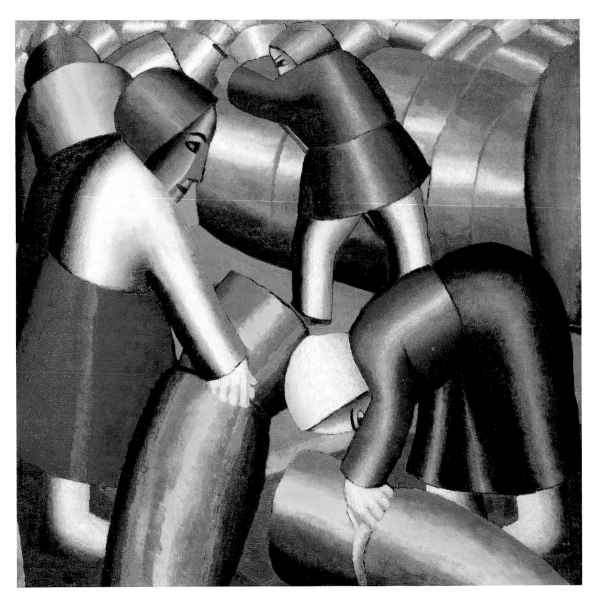

Taking In the Rye, c. 1912
Oil on canvas, 72 x 74.5 cm
Amsterdam, Stedelijk Museum

PAGE 27:
Woodcutter, c. 1912–1913
Oil on canvas, 94 x 71.5 cm
Amsterdam, Stedelijk Museum
Peasant Women in Church (p. 22) is painted
on the back of this canvas.

dency. Compare *Peasant Woman with Buckets and Child* (p. 23) with *Woman with Buckets (Dynamic Decomposition)* (p. 29), painted some three months later, and we can see that the solid Cubist construction of the former has become a pretext for a dynamic arrangement of forms, and that the silhouette of the peasant woman is doomed to disappear. In slightly less than four years, between 1911 and 1915, Malevich created no less than eight different forms of picture-making in his attempts to transcend Cézanne. Marcadé enumerates them, though he specifies that each is categorised only according to the principal style deployed, whereas each painting is in effect a complex combining several styles: gouaches and Neo-Primitivism combined with Impressionist and Fauve colour in *Bather* (p. 12, 1911–12); *lubok* in *Peasant Woman with Buckets and Child* (1912); geometrical Cézannism combined with futurism in *Taking In the Rye* (p. 26)

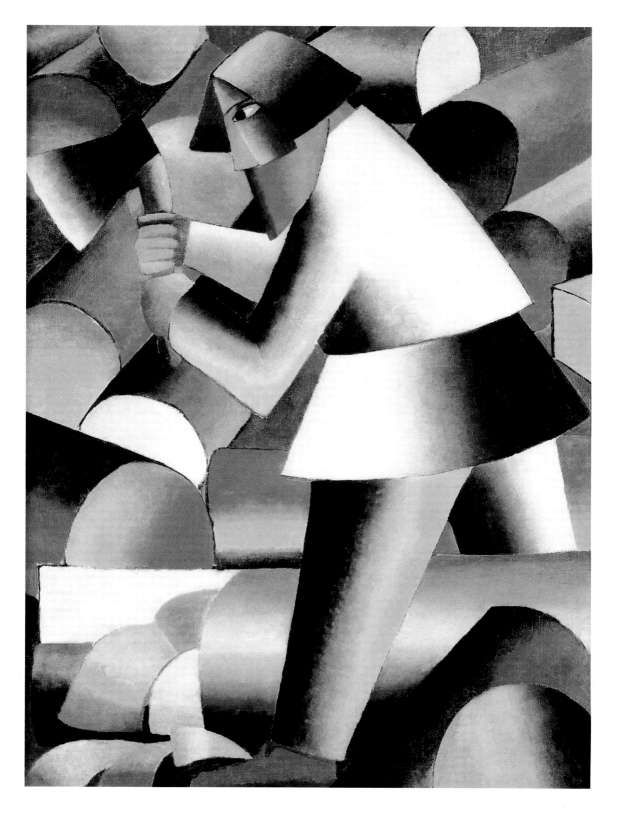

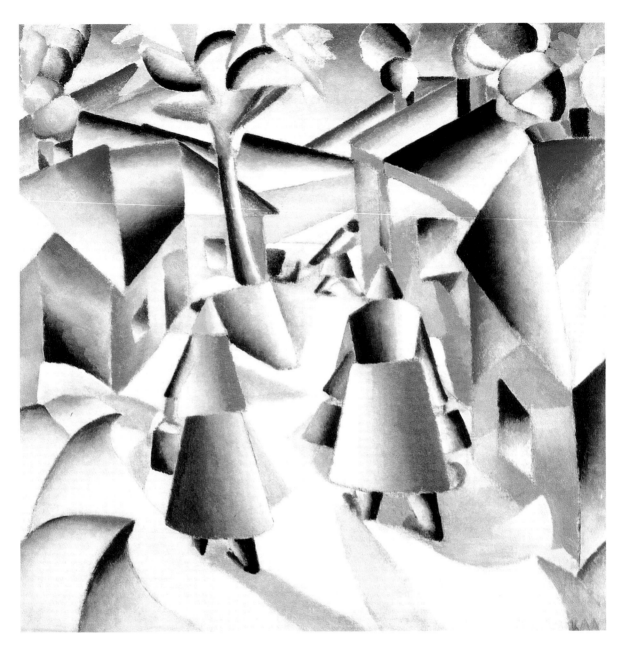

and *Woodcutter* (p. 27); "Convex" Cubo-Futurism in *Morning after the Storm* (p. 28) and *Woman with Buckets (Dynamic Decomposition)* of 1912–13; Transmental realism (zaumnyi realizm) in *Head of a Young Peasant Woman* (p. 32) or *Perfected Portrait of Ivan Vasilievich Klyun* (p. 24) in 1913; Parisian-style Analytical Cubism in *Musical Instrument/Lamp* (p. 33), *Guardsman* (p. 34), and *Woman at a Tram Stop* (p. 35); Alogism in 1914–15 with *Cow and Violin* (p. 45), *An Englishman in Moscow* (p. 46), and *Composition with Mona Lisa* (p. 47).

This astounding road – if it can be called a road – led to a logical conclusion, the monochrome quadrilateral. But what random progress, all flashes of "illumi-

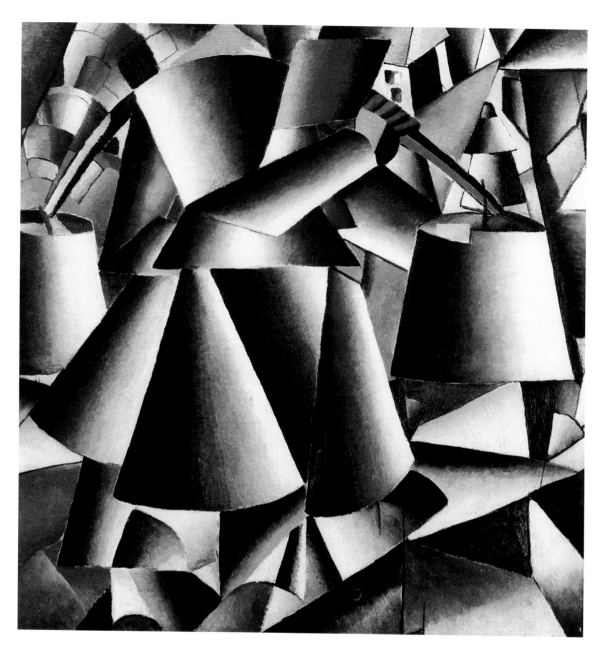

Woman with Buckets. Dynamic Decomposition of
"Peasant Woman with Buckets" (cf. page 22), 1912
Oil on canvas, 80.3 x 80.3 cm
New York, Museum of Modern Art

PAGE 28, AT THE TOP: *Morning after the*
Storm, 1912–1913
Oil on canvas, 80 x 79.5 cm
New York, Solomon R. Guggenheim Museum

PAGE 28, AT THE BOTTOM: Embroidery featuring archaic Russian motifs, Dvinsk province

nation" without any evident logic! This was a debauch of different pictorial cultures – many of them still in progress – that might have supplied less creative painters with matter for several lifetimes. Yet, even at his most Cubist, Malevich remains quite distinct from Braque and Picasso, who had sacrificed colour to analysis, confining their palette to dull colours: brown, ochre, grey and black. Malevich remained heir to the colourful Slavic tradition of popular Ukrainian art, covering the exploded geometrical elements of his various experiments with all kinds of bright hues; his works glitter with every colour in the spectrum. This feat marks Malevich out as the only artist to have contrived a brilliant and strik-

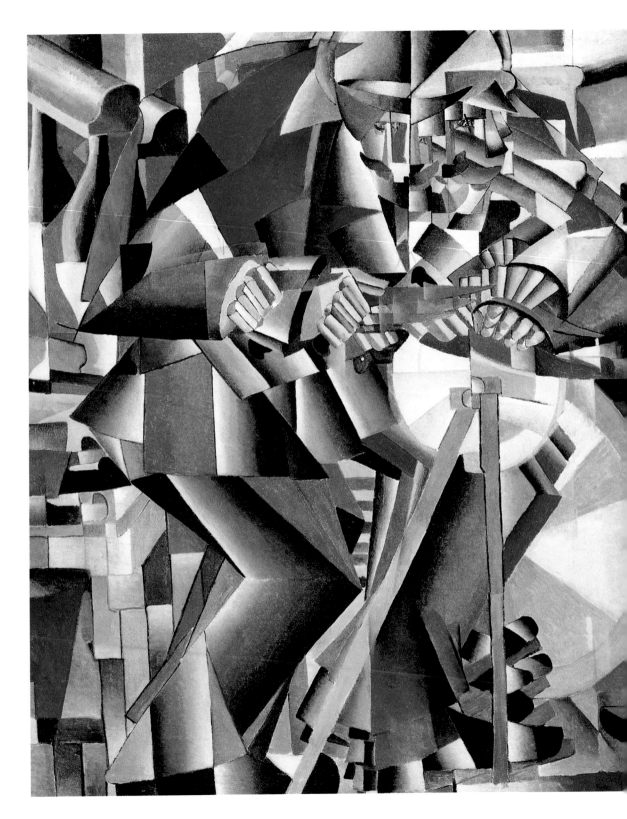

LEFT:
The Knife-Grinder, 1912–1913
Oil on canvas, 79.5 x 79.5 cm
New Haven, Yale University Art Gallery
Inscribed on the back in Russian:
"Principle of Scintillation"

BELOW:
Fernand Léger: *Woman in Blue*, 1912
Oil on canvas, 131 x 99 cm
Biot, Musée National Fernand Léger

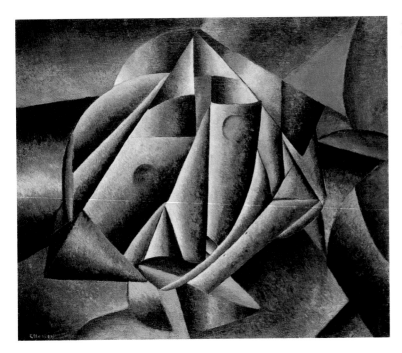

ing synthesis of Cubism and Futurism on his road toward total abstraction. To these two tendencies, he added his own dimension, that of "the all-seeing eye".

"In icons," Marcadé explains, "the eyes are those of Christ, wide open, looking out from within – across the visible – to the true reality. But in the *Perfected Portrait of Ivan Vasilievich Klyun*, the iconic eye – the iconographic archetype called "the all-seeing eye", that is, God – undergoes a "displacement" (Russian *sdvig*). The perspective is now a "Transmental" one. In a drawing from the former Leporskaya collection (p. 25), in which one part of the eye is offset relative to the other, it abuts against the axis of the nose, which is represented as an elongated parallelepiped. This makes clear the parabolic sense of double vision: internal and external eye, seeing and knowing, perception and knowledge…" And while Picasso, Braque and Gris brought all their efforts to bear on form, sacrificing colour to "local tone" and thus creating pictures of remarkable chromatic austerity, there was one painter in Paris who, like Malevich was unwilling to sacrifice any pictorial element, who was, on the contrary, intent on using them all, opposing and contrasting them to build his works from areas of flat, unmodulated colour. This was, of course, Fernand Léger, who also wished not only to liberate himself from Cézanne but to make clear his independence from Cubism. His "Contrasts of forms", derided by his adversaries as "Tubism", are close kin to Malevich's "Convex Futuro-Cubism". On has only to compare Léger's *Woman in Blue, Study* (p. 31) with Malevich's *The Knife Grinder* (p. 30) of the same year to see how closely their vision coincided.

For we should note that, at this point, Futurism was the great rival of Cubism. Futurism had come into being in 1909, but the conflict that arose in 1912 centred on the two movement's entirely incompatible aspirations. Cubism sought to bring to light the essence of the picture. Futurism saw in the picture an ideal locus for expressing the contradictions and tensions of the modern world. Only Malevich and Léger were able to transcend this distinction, rejecting both Picasso and

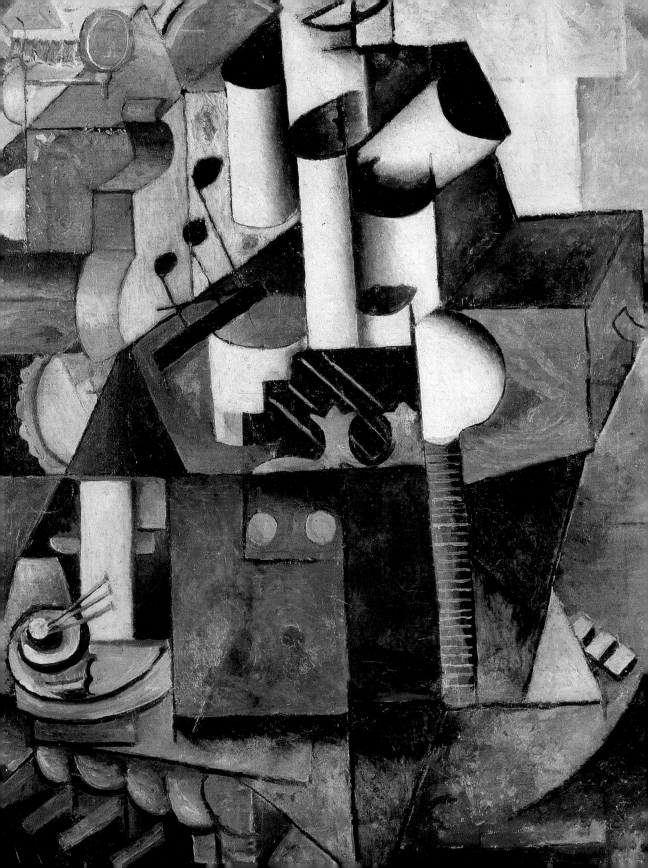

Company's flat, monochrome guitars, and Marinetti and Company's concentration on "dynamic sensation". (As Yakulov put it, Futurism "bestowed forty legs on a running dog without it moving any the more on that account".) Duchamp was another artist who attempted to take further the decomposition of form into volumes that he found in Cézanne; the result was a still more dissolved vision of reality, recorded in almost total monochrome. Malevich and Léger answered Duchamp's *Nude Descending a Staircase* with their multiple artisan- and woman-robots composed of hundreds of flights of stairs, while Duchamp abandoned traditional painting in disgust. Aware of the challenge thrown down by technology to the aesthetic, he turned instead, in 1914, to the "ready-made": in the first of these, *Bicycle-Wheel* – a wheel fixed by its fork to a stool so as to turn freely – he found a way of replacing the movement implied in his famous staircase.

Another difficulty shared by Malevich and Léger was the insistence of the establishment that neither "intellect" nor "emotion" could or should have any part in their work of the time. "Mystery" and "mysticism" were still more dishonourable. The unremitting "call to order" of Communist aesthetics has left

The Guardsman, 1913–1914
Oil on canvas, 57 x 66.5 cm
Amsterdam, Stedelijk Museum

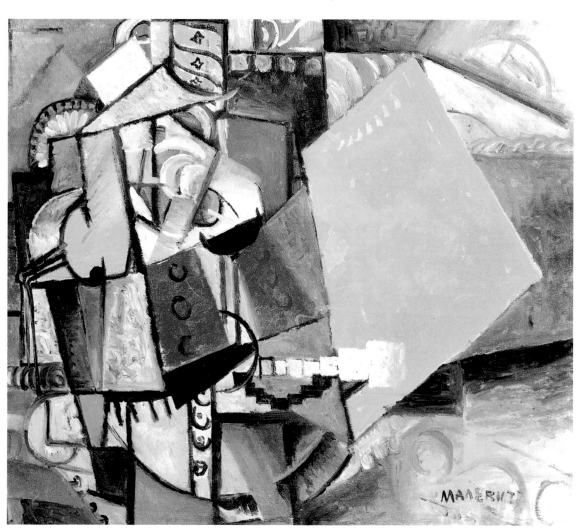

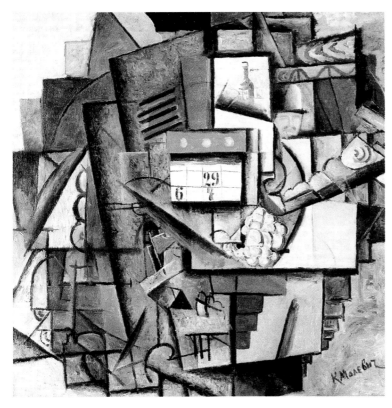

Woman at a Tram Stop, 1913
Oil on canvas, 88 x 88 cm
Amsterdam, Stedelijk Museum

Pablo Picasso: *Musical Instruments*, 1912–1913
Oil on canvas, 72.5 x 60 cm
Private collection

little to admire. Stalinism could accept only the formal aspect of Malevich's works, and Roger Garaudy, a member of the Central Committee of the French Communist Party and orthodox Marxist, considered Léger's painting devoid of all philosophical speculation; the only terms in which it could be understood, he said, were those of its plastic construction. The Communism of the day was a fastidious master, anxious to eliminate the remotest possibility of art causing disturbance. Garaudy, who penned works such as *A Materialist Theory of Knowledge* and *God is Dead*, delimited the acceptable interpretation of Léger's work in a manner that the Soviet art commissars might easily have applied to Malevich: "He would happily make fun of those who see in abstract painting a model of metaphysical knowledge or of mystic participation in the profound or mysterious reality of things. He does not pretend to reveal the thought of God, the intellectual laws or forms that create the trees or the movement of the stars. He always aspires to be a constructor, not a liberator, and he seeks in the abstract forms of immediate visual reality pure plasticity, stripped of the waste materials of the pictorial subject and even of the object as such." In his works of this period, Malevich too condensed objects and figures into tubular form, in pictures like *Morning after the Storm* and *Woman with Buckets (Dynamic Decomposition)*. Both artists depicted a *Woodcutter* using a play of circles and cylinders in which the interlocking volumes produced a mechanical effect that their increasingly metallic colours could only enhance. True, both artists were, at the time, struggling with the challenges of form and colour. But can one really assert that these two eminent artistic thinkers brought to their work neither "intellect" nor "emotion"? That Léger thought only of "contrasts of forms" and Malevich only

У ЗЛАТА ЗАРЕВО
ОГНЕЙ
И СѢДИ НА БОЛЬНѢЙ
ОНА НИЧТОЖНА И
СЛАБА
ПРЕД НЕЙ КОЛЫШЕТ-
СЯ РѢЗЬБА

И ЧЕРТ РОСПИЛЕ-
НЫЙ И СТРУЖКИ
КАК ЗМѢЙКИ В ВОЗ-
ДУХѢ ТОРЧАТ
ТАКІЯ РѢЗВЫЯ ИГРУ
ШКИ
ГЛАЗА ВОЗЖЖЕННЫЯ
СВѢЖАТ

БЫТЬ ОТПУЩЕНЫМ
БЕЗ ПѢСНИ
БЕЗ УТѢХИ И СЛЕЗЫ
ТОЧНО ПАРУБКИ НА
ПРѢСНѢ
КЛАДБИЩ ВЫХОДЦЫ
МЕРЗЛЫ
ЛЮБОВНИЦУ КОЙ ОТРАВЫ
СѢЛА

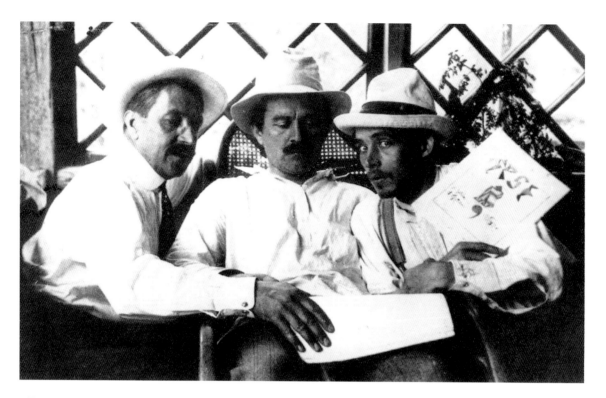

of "Convex Cubo-Futurism"? What would be the point of such highly-achieved vacuity? Were they themselves robots without soul?

It is a curious fact, that the closer abstraction came, the more commonly it was described as realism. Gleizes and Metzinger, in their 1912 work *On Cubism* (a work much admired in Russia), launched the notion of "Universal realism". This occurred, they said, in "regions where profound realism was imperceptibly transformed into luminous spiritualism", a region that Cézanne had, they said, come close to. There is some continuity with this in Léger's famous lecture on *The Origins of Painting and its Representative Value*. He read this for the first time in 1913, at the Académie Marie Vassilieff, and thus to a predominantly Russian audience. "The *realist* value of a work is entirely independent of any imitative quality… Pictorial realism is the simultaneous ordering of the three great plastic qualities: line, form and colour." And between 1913 and 1914, Malevich significantly classified his paintings into two categories: "Transmental realism" and "Cubo-Futurist realism". In 1915, he returned to this, calling Suprematism, his "non-objective whole", the "New Pictorial Realism". In similar fashion, the Pevsner brothers and Naum Gabo entitled their 1920 pamphlet calling for a new form of sculpture "without objects" *Realist Manifesto*.

There remains the mystery of "Transmentality". Marcadé tells us that the word derived from the processes of poetry. "Zaum" (Transmentality or transrationality) was how the Cubo-Futurist poets Velimir Khlebnikov and Alexander Khruchenyk described their poetic language: "beyond reason" is its literal meaning. Their theory dated from around 1913, when Khlebnikov gibed that Kant had defined not the limits of reason, but the limits of German reason. Malevich further extended the frontiers of the transmental in the style that, in 1913–14, he dubbed "Alogism".

Photograph of Matyushkin, Malevich, and Khruchenyk in Matyushkin's *dacha* in Uusi-kirkko, Finland, during summer 1913. Elena Guro, Matyushkin's wife, had just died, and Khruchenyk holds the cover, designed by Malevich, of the poetry collection *The Three*, dedicated to her.

PAGE 36:
Devil, 1914
Lithograph, 16 x 14 cm
Page 19 of Khruchenyk and Khlebnikov's poem, *Sport in Hell*, 2nd ed., Saint Petersburg. The drawing is by Malevich, the text is handwritten by Olga Rozanova.

We have already seen one splendid example of this Alogism in the *Perfected Portrait of Ivan Vasilievich Klyun*. Another masterpiece of predominantly Alogist style is *Head of a Young Peasant Woman* (p. 32). The headscarf worn by Russian peasant women and knotted under the chin is clearly drawn. The transmentality of the image is manifested in the complete dislocation of the oval of the face, which is inserted into the neckscarf as if into a carapace of metal, painted almost monochromatically Brunswick blue. The face seems to have been sliced, and the eyes have lost their Byzantine slant to become two circles; the beauty of the portrait resides in its harmonious distribution of geometrical planes. Cézanne could be proud of his follower here, for Malevich has gone beyond Cézanne's wildest dreams. In *From Cézanne to Suprematism*, Malevich explained his proceeding: "the whole point was not to render the plenitude of the object; on the contrary, it was indispensable to pulverise it and decompose it into its constituent elements in order to create pictorial contrasts. The object was considered in its intuitive aspect…".

But soon Malevich's Cubism got the better of his Futurism, and Cubo-Futurist Realism overcame Transmental Realism. Moreover, his Cubo-Futurist Realism was quite content to incorporate certain techniques invented by Braque and Picasso, collage in particular. In 1912, the two Cubists in Paris were making fre-

Costumes and sets for Matyushkin's opera "Victory over the Sun", 1913
Saint Petersburg, National Museum of Theatre and Music

LEFT: *Fifth Tableau. Square*
Graphite on paper, 21 x 27 cm

The word "square" has been added in Malevich's hand, the artist always having claimed that 1913 was the year in which the Suprematist square first appeared.

AT THE TOP, LEFT: *Second Action, Sixth Tableau. House.* Graphite on paper, 21.3 x 27 cm

AT THE TOP, RIGHT: *First Action, Second Tableau. Green and Black*
Graphite on paper, 17.5 x 22 cm

PAGE 39: *Costume of the "New Men"*
Graphite, watercolour, and Indian ink on paper, 26 x 21 cm

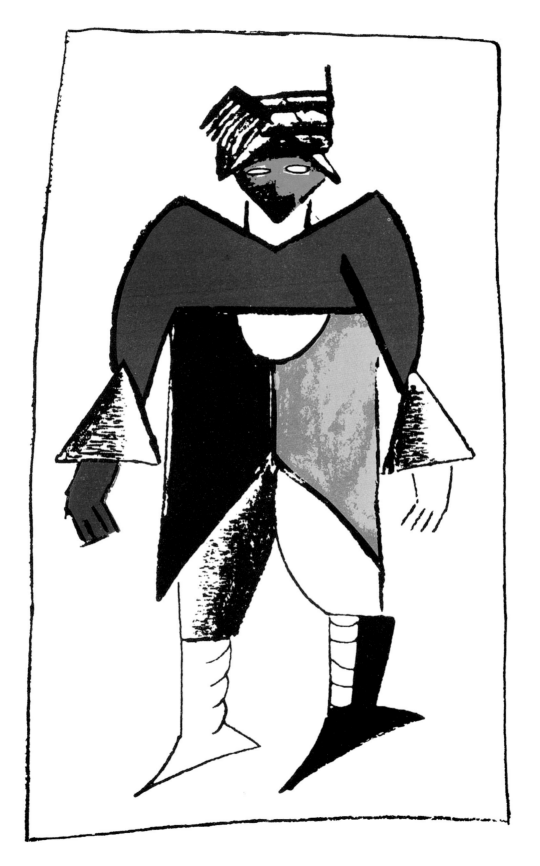

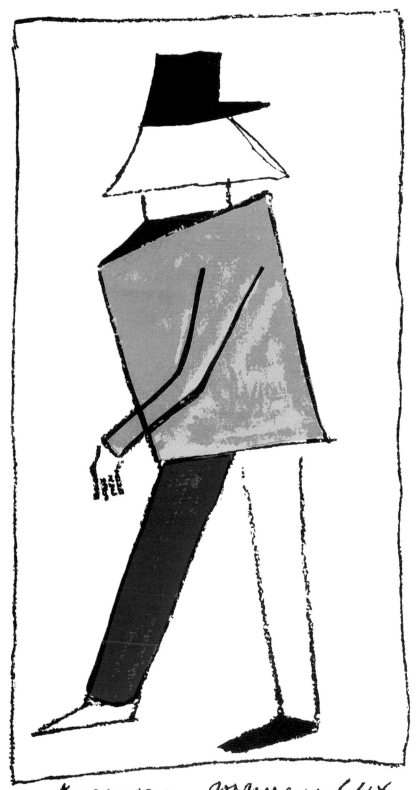

коотном шруанилих

quent use of quadrilaterals to structure the surface of the painting, for example, Picasso in his *Violin* (p. 35). Malevich saw the formal benefit of this, and the cylinders of Cubo-Futurism gave way to the squares, rectangles, trapeziums, and parallelograms of *Musical Instrument/Lamp*, *Guardsman* and *Woman at a Tram Stop*. These pictures bear witness to the influence in Russia of Analytical Cubism, and in Malevich to his evolution from Cubo-Futurism to Transmental Realism and on to Analytic Cubism. In *From Cézanne to Suprematism*, he specifies that in dissonance he had found the new beauty of objects, thanks to what he calls the intuitive creative feeling: "Objects have in them a multitude of temporal moments, their aspect varies, and consequently the painting of them also varies. All these temporal aspects of objects and their anatomy (a layer of wood, or other such)… are seized by intuition as a means of constructing the picture; by that process, these means are constructed such that the unexpected character of the meeting of two anatomical structures creates a dissonance, giving rise to a force of extreme tension, which justifies the appearance of parts of real objects in places where they do not appear in nature. Thus we have preferred the dissonance of objects to the possibility of representing the totality of the object. We can therefore state with relief that we have ceased to be the two-humped camel loaded with the rubbish cited above."

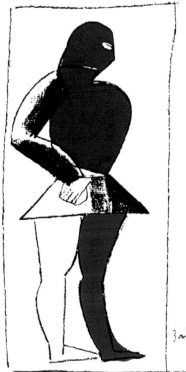

Woman at a Tram Stop is a fine illustration of Malevich's declared intention "not to render objects, but to make a picture". In this thicket of quadrilateral forms, the outcome of a search for either "woman" or "tramway" must remain uncertain. Nothing is left of the tram but its number plate, and the face that appears in a window is not that of a woman but of a man in a bowler hat. Malevich's humour certainly derives from Ukrainian and popular Slavic art, and is omnipresent in his work. The messages conveyed by this humour are not invariably perspicuous, but it comes into its own in the period 1913–15, when Alogism predominates in Malevich's painted work. This time, the picture's function of representing the physical world was entirely abolished in favour of the absurd. Malevich thus snubbed his nose at Braque and Picasso's collages, and foreshadowed the gestures of Dada and Surrealism. For example, in *Cow and Violin* (p. 45), he placed the violin so beloved of the Parisian Cubists on the same footing as a cow, using mutually incompatible scales; this absurdist gesture abolished the image of the figurative object, and evokes the famous sentence of Lautréamont's (later confiscated by the Surrealists): "As beautiful as the chance encounter on a dissection table of a sewing-machine and an umbrella". A real wooden spoon was stuck to the hat of the *Englishman in Moscow* (p. 46), ironically erasing the distinction between the functional and the painted object. In short, Malevich introduced a Duchamp ready-made into a Picasso-style Cubist painting, thus questioning their relative status. A reproduction of the *Mona Lisa* lies at the heart of *Composition with Mona Lisa* (p. 47), which carries the inscription "partial eclipse", while two collage fragments offer an "apartment to let in Moscow" just beneath Leonardo's most famous work, itself crossed out with several red lines; this manifesto against a reliance on the past is comparable to the moustaches Duchamp added to the

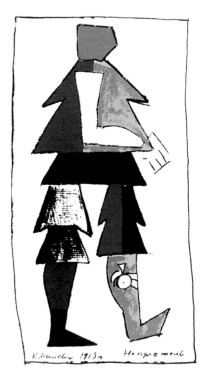

AT THE TOP: *The "Squabbler"*
Graphite, watercolour, and Indian ink on paper,
26.7 x 21 cm

PAGE 40:
Costume of the "Cowards"
Graphite, watercolour, and Indian ink on paper,
26.9 x 21 cm

RIGHT: *The "Enemy"*
Graphite, watercolour, and Indian ink on paper,
27.1 x 21.3 cm

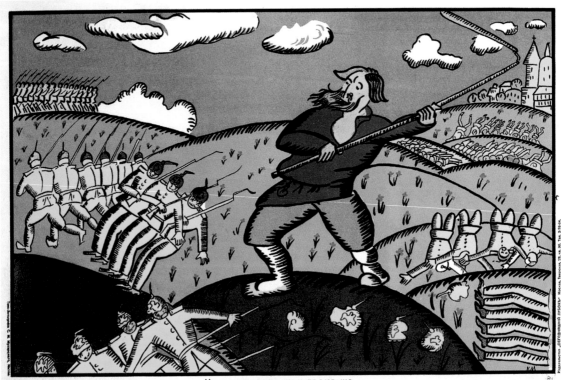

Ну и трескъ-же, ну и громъ-же
Былъ отъ нѣмцевъ подлѣ Ломжи!

Patriotic Luboks, 1914
Drawings by Malevich, words attributed
to Mayakovsky

ABOVE:
*"What a racket, what a din the Germans made
near Lomya"*
5-stone lithograph, 33.2 x 51.1 cm

PAGE 43, AT THE TOP:
*"Hey! Look, the Vistula is close: the Germans are
swelling up – things look bad"*
5-stone lithograph, 32.8 x 49.5 cm

PAGE 43, AT THE BOTTOM:
*"The Austrian was going to make himself into a
Radziwill and here is on the end of a serf's fork"*
5-stone lithograph, 32.8 x 49.5 cm

Mona Lisa. Malevich articulated this condemnation in *From Cubism to Suprematism*, where he states: "A face depicted in a picture offers a pitiful parody of life".

Alogism can be perceived in one light as a new avatar of the "transrationality" (*zaum*) that had already defined certain of Malevich's works in 1912–13. But this time his works attracted a certain following. In a letter of early 1913, Malevich addressed the composer, painter and theoretician Matyushin in these terms: "In rejecting reason, we base ourselves on the fact that another reason has grown up in us. By comparison with what we have rejected, we might call this *beyond reason*, though it is itself governed by a law, a construction and a sense, and it is only by understanding it that we shall attain an *œuvre* based on the law of this genuinely new *beyond-reason*. It is through Cubism that this reason can transmit the nature of the object." Malevich wanted to go beyond Cubism, beyond Futurism, and now beyond reason, and he was assisted in this by a group of like-minded friends. It included Matiushkin, a highly intuitive painter and composer, Elena Guro, a poetess who died young, Olga Rozanova, a daring painter, and the poets Khlebnikov and Khruchenyk. The two last-named had originated the notion of a transmental poetry, freed of the constraint of words in its aspiration to expression: the notorious *zaum*. They felt that, by a partial or complete application of *zaum*, they could transcend the sense of the common word. Their notion of an abstract language having no recourse to existing words corresponded to Malevich's dream of a form of painting liberated from objects and reference.

The three men – Matiushkin, Khruchenyk and Malevich – became inseparable. They spent the summer of 1913 in Uusikirkko, Finland, where they drafted

a manifesto condemning "cowardice and stick-in-the-mud-ism" and "artistic feebleness"; it called upon the forces of poetry and the visual arts.

Enthused by these intentions, the three set about a series of collaborative works, which include the poetry collection *The Three* (poems by Khlebnikov, Khruchenyk, and Elena Guro, with illustrations by Malevich). Their efforts culminated in the opera "Victory over the Sun".

Before proceeding, we should however add an excursus on what has been called the "patriotic Lubok of 1914". Malevich was interrupted at the height of his Alogism with a request that he take part in the production of texts and images devoted to anti-German propaganda, to attacking the new invaders who came armed not with -isms but with guns. The structures of *lubok* had served as the conceptual and poetic base of Russian Neo-Primitivism and Cubo-Futurism; now Malevich and a wide range of other artists were called upon to make true *luboks*, simply updated for modern taste. The heroes that Malevich chose were of course the Russian peasants, the grandmothers impaling the German "butchers" on their hayforks. The texts of these *luboks* have been attributed to Mayakovsky (pp. 42–43).

The great precursor of the Futurist's innovative picturo-poetic books of 1913 was, of course, Stéphane Mallarmé. Moreover, his reflections on the rhythmic origin of the art were essential to the conception of the opera *Victory over the Sun*. Mallarmé's *Un Coup de dés jamais n'abolira le hasard* (1897) brought musical procedures to the written world, creating a kind of typographic score. In *Un*

Глядь, поглядь, ужъ близю Вислы
Нѣмцевъ пучитъ, значитъ кисло!

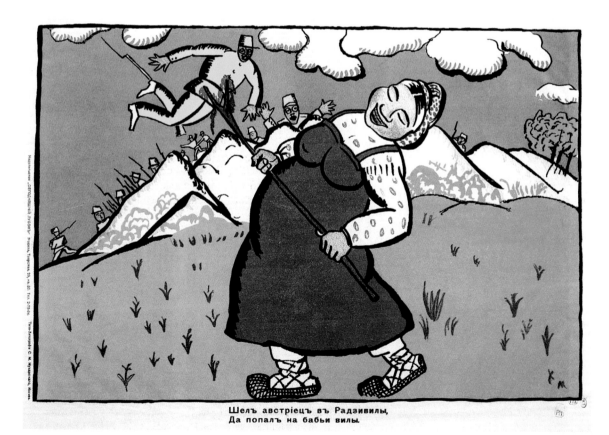

Шелъ австріецъ въ Радзивилы,
Да попалъ на бабьи вилы.

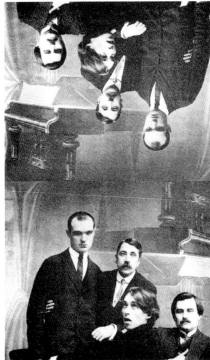

Alogist male and female figures, c. 1916
Costumes for Lermontov's verse play *Masked
Ball*, directed by Meyerhold.
LEFT: *Female*
Pencil on paper, 16.6 x 10.7 cm
Former A. Leporskaya Collection
RIGHT: *Male*
Pencil on paper, 16.5 x 10.8 cm
Cologne, Museum Ludwig

CENTRE: *Zaum* photograph showing the pro-
tagonists of the Cubo-Futurist events staged
at the Luna-Park Theatre, Saint Petersburg in
December 1913: *Vladimir Mayakovsky. Tragedy*,
and *Victory over the Sun*. Right to left: Filonov,
Matyushkin, Khruchenyk and Malevich. When
the characters have their feet on the ground, the
piano's legs rest on the ceiling, and vice-versa.

PAGE 45:
Cow and Violin, 1912–1913
Oil on canvas, 48.8 x 25.8 cm
Saint Petersburg, State Russian Museum

PAGE 46:
An Englishman in Moscow, 1914
Oil on canvas, 88 x 57 cm
Amsterdam, Stedelijk Museum
The inscription in Cyrillic capitals reads:
"Partial Eclipse".

Coup de dés we have the seed of the future "poem-picture" of the Italian, French
and Russian Futurists. Marinetti, Khruchenyk and their followers in poetry
and the visual arts merely developed the "rhythm of the book" of which Mal-
larmé speaks in his Preface to *Un Coup de dés*. Moreover, Marcadé observes
that, in Russian, "the verbs "paint" and "write" are rendered by a single verb
(*pisat*). This confusion speaks to the original form of the act of representation,
when calligraphy was naturally pictographic, whether it served to transmit
information or create magic relationships with the mysterious forces of the
world."

Thus, in *Game in Hell* (p. 36), there is a certain consonance between the text,
handwritten by Olga Rozanova, and the primitivist spirit of the *lubok* in Male-
vich's graphic equivalents. The complementarity and reciprocity of Khruche-
nyk's libretto, Khlebnikovs' prologue, Matyushin's music and Malevich's decors
and costumes constitute one of the great triumphs of *Victory over the Sun*. The
opera is a landmark in the evolution of the arts in the 20th century. It was at once
a first attempt at "total" spectacle – a complete departure from theatrical norms
– and what one might today call a "happening". Needless to say, the scandal was
"Cyclopean". People screamed "Down with the Futurists! Down with the scan-
dalists!" Khruchenyk, something of a connoisseur of brickbats, whistling and
jeers, was delighted. But, as Matiushkin reports, nothing could attenuate the
dramatic impression made by the opera "so great was the inner strength of the
words, so powerful and terrifying were the never-before-seen decors and Fu-
turaslavs, so tender and supple was the music that enfolded in its tendrils the
words and pictures and the Futuraslav giants who had so easily conquered the
sun of appearances and kindled their own inner light".

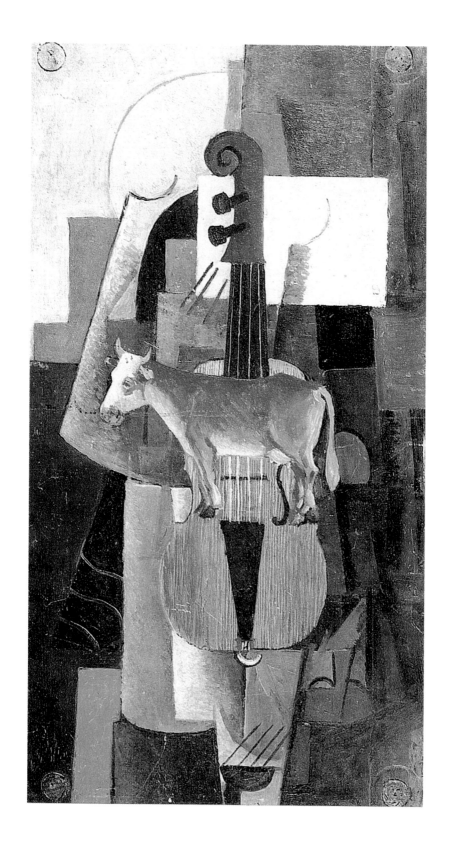

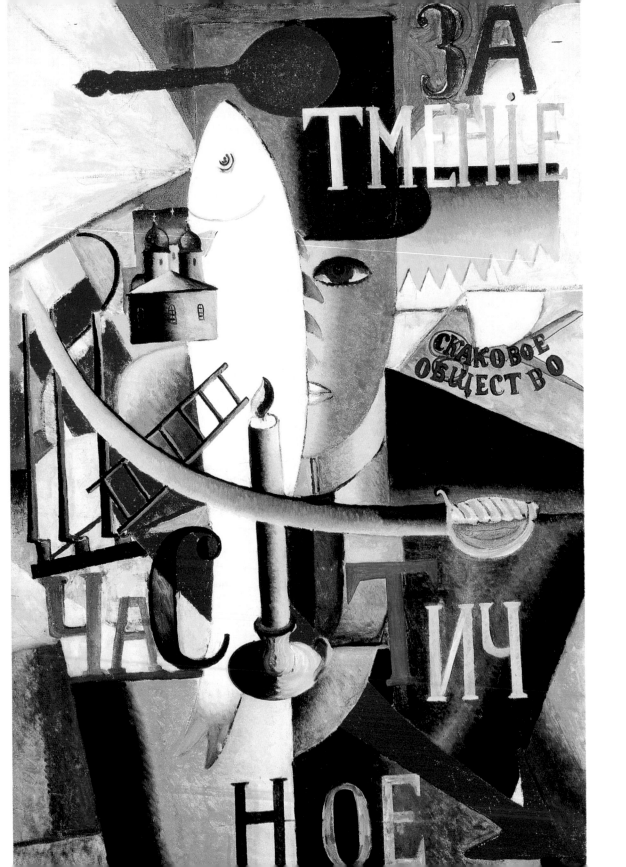

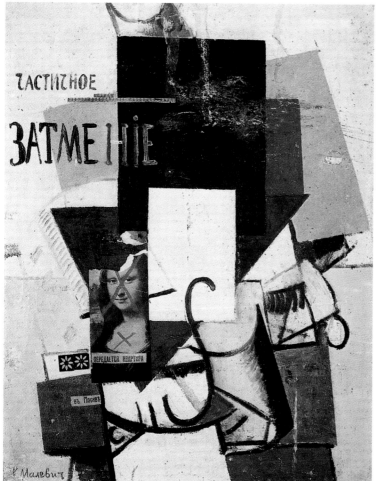

What a Cheek!, c. 1915
Pencil on paper, 16.3 x 11 cm
Former A. Leporskaya Collection

Victory over the Sun marked a new beginning for Malevich. When Matyushin sought to publish the libretto, Malevich begged him to include "were it only my drawing of the curtain, in the act in which Victory is consummated… This drawing will prove vitally important for painting…" The curtain was in fact the first *Black Square* (p. 38) and though the first truly Suprematist paintings came only in 1915, Malevich always dated the birth of Suprematism to 1913 and the curtain of *Victory over the Sun*.

Black Square and Tubular White Form,
c. 1915–1916
Pencil on paper, 16.3 x 11.5 cm
Paris, Musée national d'Art moderne –
Centre Georges Pompidou

AT THE TOP: *Composition with Mona Lisa
(Partial Eclipse in Moscow)*, c. 1915–1916
Oil on canvas, 71 x 54 cm
Former A. Leporskaya Collection

RIGHT: *Square, Circles and Arrow*, c. 1915–1916
Pencil on paper, 16.3 x 11.7 cm
Cologne, Museum Ludwig

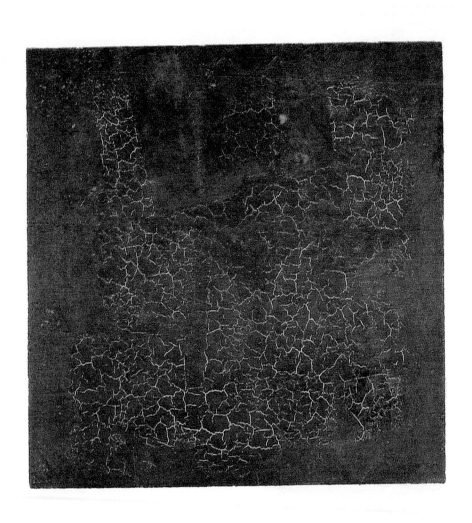

The Cosmos
within the Skull
1915–1926

In 1978, an international conference was held at the Centre Pompidou to mark the Malevich exhibition of 1978 (the papers were published under the editorship of J. C. Marcadé). Competing approaches to the work of Malevich came into memorable confrontation: "The black square is not figurative!" "Oh, yes, it is, it is an exemplary case of figuration". "Exemplary? In what respect does it exemplify figuration?" "It is the figure as emblem, it is emblematic of the figure" "Ah, the emblem now! Why not the symbol, too, while you're at it?" Why not indeed? The quarrels that began in Malevich's lifetime have not yet been resolved. There are "believers" and "atheists". And there are also Malevich's own writings, invariably dense and often obscure.

When the critic Alexandre Benois penned an article that he found offensive, Malevich replied: "You who are in the habit of warming yourself before sweet little faces, find it hard to get any warmth out of the face of a square… The secret of incantation is the very art of creation. It is an art within time, and time is greater and wiser than pigs!" Kandinsky had declared in his *The Spiritual in Art*: "If we were, this very day, to cut our links with nature and tear ourselves free of her without hesitation or prospect of return, if we were to content ourselves with nothing more than combining pure colour with some invented form, the works that we should create would be ornamental and geometrical, and not at first sight very different from a tie or a rug." Malevich replied that his Suprematist system "is constructed in time and space without depending on any aesthetic beauty, emotion or state of mind whatsoever; it is rather the philosophical system coloured by the new movements of my representations, as cognition." In his virulent and ironic response to Benois, Malevich announced that his square was "a naked icon without a frame (like my pocket), the icon of my time. But my good fortune in not resembling you gives me the strength to go further and further into the void of the deserts, for only in this place does transfiguration exist. You will never see the smile of a pretty little Psyche on my square! It will never be the mattress of love!"

And, in imitation of the "beautiful corner" where the icons are placed in the traditional Orthodox household – the visitors turns toward them on entering and cross themselves – Malevich displayed his icon high in the corner of the room in which he first exhibited it. This was in December 1915, at the *Last Futurist Exhibition "o.1"*, held in the Nadezhda Dobychina Gallery in Saint Petersburg

Oval, Rectangle, Square, Curve, 1920s
Black chalk on paper, 35 x 22 cm
Amsterdam, Stedelijk Museum

AT THE TOP:
Pictorial Realism of a Two-Dimensional Peasant Woman [commonly referred to as *Red Square*], 1915
Oil on canvas, 53 x 53 cm
Saint Petersburg, State Russian Museum

PAGE 48:
Quadrangle [commonly referred to as *The Black Square*], 1915
Oil on canvas, 79 x 79 cm
Moscow, Tretyakov Gallery

(pp. 54–55). The square had, in a sense, replaced the more traditional holy triangle: "Modernity is not easily contained in the ancient triangle, for its life is currently quadrangular." Indeed, Malevich first entitled his work *Quadrangle* (p. 48), since his "black square" was not strictly square: its pairs of sides were not parallel, equal, nor at right angles to one another. The same is true of his *Red Square (Pictorial Realism of a Two-Dimensional Peasant Woman*, p. 49*)*. Nor did Malevich conceive his square as nihilistic. On the contrary, he viewed it as a culminating point: painting, sculpture, the applied arts and even writing would have to be reformed and reconceived in the light of it. His *tabula rasa* was the precondition of a renaissance. This is what Malevich's most brilliant disciple, El Lissitzky, declares in his *The Conquest of Art* (1922): "Yes, the path of pictorial culture has narrowed till it reached the square, but over on the other side a new culture is beginning to bear fruit. Yes, we salute the audacious man who threw himself into the abyss in order to restore the dead to life in another form. Yes, the pictorial line has descended regularly… 6, 5, 4, 3, 2, 1, to 0, but at the other extremity a new line begins, 0, 1, 2, 3, 4, 5, …"

"Why not the symbol?" was the ironic protest heard at the 1978 conference. True, Malevich proclaimed during the *0.10* exhibition: "I have transfigured myself in the zero of forms". According to Anna Leporskaya, his student and assistant, when the black quadrangle appeared under his brush, Malevich "neither knew nor understood what the black square contained. He thought it so important an event in his creation that for a whole week he was unable to eat, drink or sleep." In theory, the *Black Square on a White Background* has no meaning beyond itself. And yet Malevich on occasion described the *Red Square* as a revolutionary sign and the *Black Square* as a sign of his own death. Though its function was to exist rather than to mean, Malevich could not help thinking of his *Square* when he wrote about the anarchist flag: "Insofar as there is in the [anarchists'] black flag the idea of the liberation of the personality as something isolated and unique, its idea must find expression in the white, as substance without diversity, in every respect unchangeable". In other words, for all that Malevich condemned symbolic interpretations, he inevitably fell into the same trap himself. In his *Tertium Organum* (which Malevich may have read), Ouspensky cited Lao Tse: "The Tao is a large square without angles, a great sound that cannot be heard, a great image that has no form". The cross, too, is an abstract sign. But, as Adolf Loos wrote in his pamphlet *Ornament and Crime* (1908), the cross was,

before becoming the symbol of Christ, a prehistoric erotic symbol. It was the work of *homo eroticus* before he became *homo sapiens*: "the first ornament ever to appear, the cross, was of erotic origin. The first work of art, the first erotic gesture by which the fist artist gave free rein to his exuberance by scribbling on a wall, was erotic. A horizontal line for the reclining woman; a vertical line, the man penetrating her…" Like it or not, it is difficult for abstract art to maintain an abstract existence. Wholly abstract art would have to be invisible: an empty frame. God is abstract because invisible. Malevich's intention was not to emulate God, merely to represent "the objectless world". At best, one might speak of non-figurative art. The artist or spectator will invariably give a personal sense to a work, however lacking in subject the work may seem. The apparently abstract signs of Chinese writing are in fact ideograms. The calligraphy of a musical note, a Japanese *katakana*, represents a sound. Leonardo advised his students to stare at the cracks and flaking of a wall, seeing in it a superb sketch of battle.

As Serge Fauchereau observes, "Over and beyond the rich symbolism of colour (especially rich in revolutionary Russia), we must take account of something omitted in the simple translation *Red Square*, the fact that in Russian *red* and *beautiful* are one and the same word. (Moscow's Red Square was so named well before the Revolutionary epoch because it was the most beautiful square in the town.)" For Malevich, the *Red Square* was also the *Beautiful Square*, and in his own iconology, the *Two-Dimensional Peasant Woman* appears in all her splendour. His provocative humour comes to the surface in the far-fetched titles he bestowed on certain of his Suprematist pictures: *Pictorial Realism of a Foot-baller, Self Portrait in Two Dimensions, Coloured Volumes in the Fourth Dimension, Pictorial Realism of Little Boy with his Satchel, Automobile and Lady*, and so on. These were accompanied by warnings: "The titles I have given certain paintings are not intended to suggest that one must look in them for those forms, but that real forms have been considered by myself primarily as heaps of pictorial volumes devoid of form, on the basis of which a pictorial painting has been created that is nothing to do with nature". Suprematism was about not forms but and sensation: "The artist seeking to express the entirety of his sensation of the world does not elaborate colour in form, but forms the sensation, since the sensation determines the colour and form, so that one should rather speak of the correspondence of colour to sensation than its correspondence to form, or indeed of the correspondence of colour and form to sensation". The

Drawing strip, Bauhaus notebook, Suprematist compositions for "The Non-Objective World",
1920s
Basel, Kunstmuseum

RIGHT TO LEFT:
Movement of the Suprematist square creating a new biplanar Suprematist element
Pencil on paper, 20.5 x 26.5 cm

Elongation of the Suprematist square
Pencil on paper, 20.5 x 26.5 cm

Suprematist group
Pencil on paper, 20.5 x 26.5 cm

Suprematist compositional elements
Pencil on paper, 21 x 16.4 cm

Suprematist group with use of triangle form
Pencil on paper, 20.9 x 16.4 cm

colours of which Malevich speaks are, for example, those of the Novgorod school of icon painting: the white breast of the horse and the bright red of the habit in *Saint George the Victorious* or the white episcopal stole studded with black crosses in *Saint Nicolas*.

In Malevich's Suprematism, colour is omnipresent and invariably radiant. It is no longer what it was to the Impressionists, the "product of the decomposition of light", but something quite other, as he explains in his opuscule on *Light and Colour*: "We don't know who colour belongs to: to the Earth, Mars, Venus,

the Sun or the Moon? Is it not simply that colour is that without which the world is impossible? Not the colours that are boring, monotonous, and cold, the blind man's naked form (that stupid Alexandre Benois is ignorant of the joy of colour). Colour is a creator in space!" Space is the key word here. The lessons Malevich learnt from Cubism and Futurism were two essential elements of the pictorial: gravity and weightlessness (the static and the dynamic). "The Earth is abandoned like a house that the termites have gnawed through and through…", he wrote in 1916; "The flat suspended plane of pictorial colour on the white

PAGE 54/55:
Photograph of *The Last Futurist Exhibition, 0.10*, at the Gallery Nadezhda Dobychina, Saint-Petersburg (opening date: 30 December 1915)

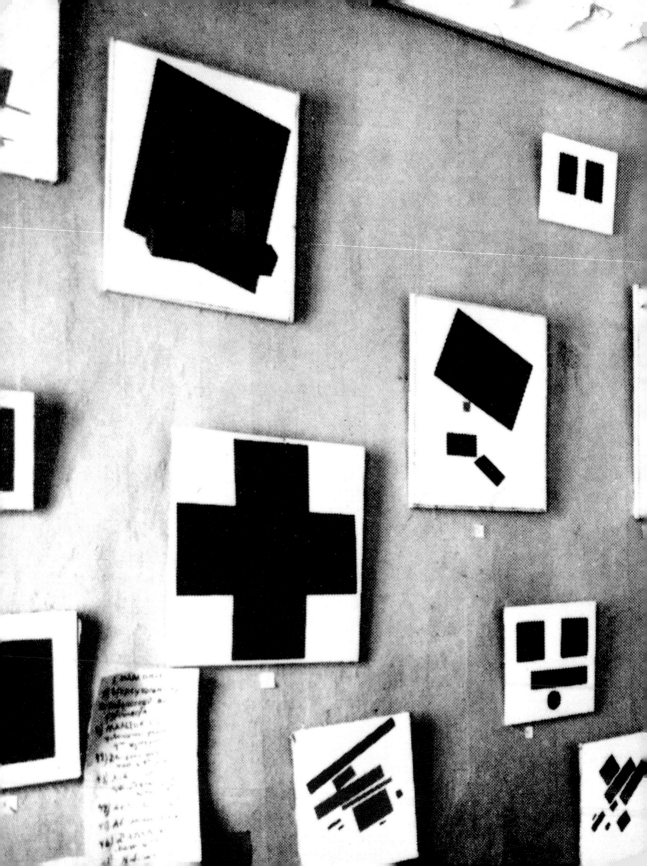

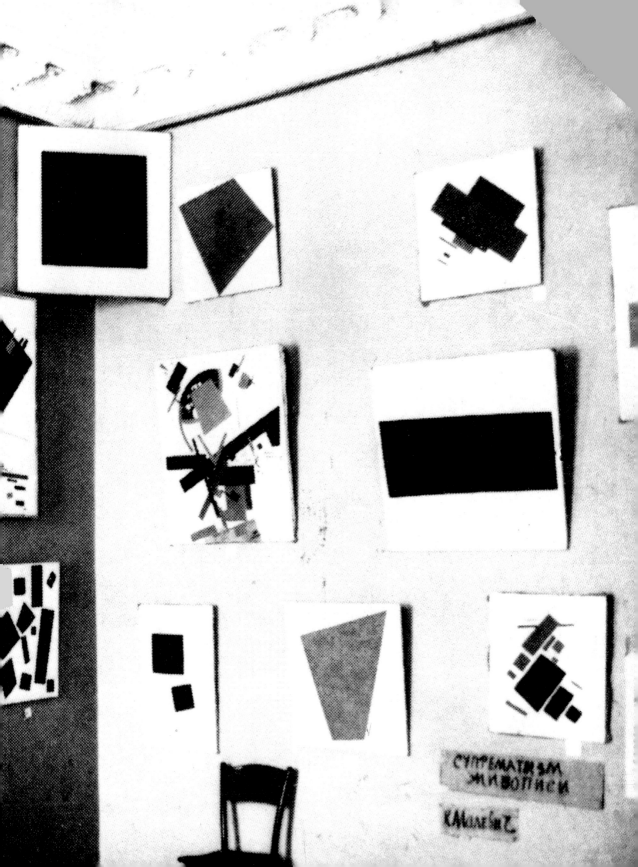

...tism with Blue Triangle
...gle, 1915
... x 66.5 cm
...delijk Museum

PAGE 57: ...*Square and Red Square*, post–1920 (?)
Oil on canvas, 82.7 x 58.3 cm
Ludwigshafen, Wilhelm-Hack-Museum

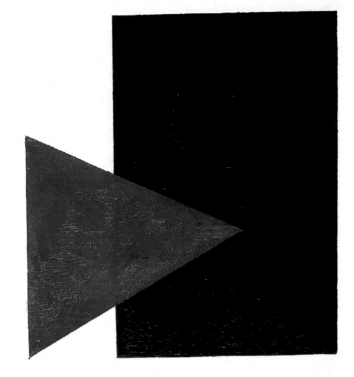

PAGE 58: *Eight Rectangles*, 1915
Oil on canvas, 57.5 x 48.5 cm
Amsterdam, Stedelijk Museum

PAGE 59: *Suprematist Painting. Aeroplane in Flight*, 1915
Oil on canvas, 57.3 x 48.3 cm
New York, Museum of Modern Art

BELOW: Cover of Malevich's brochure:
On Cubism and Futurism, the New Pictorial Realism, 1916

canvas immediately gives us a strong sensation of space. I feel myself transported into a desert abyss in which one feels the creative points of the universe around one… Here (on these flat surfaces), one can obtain the current of movement itself, as if by contact with an electric wire."

Cubism, Futurism and Cubo-Futurism were mired in the birdlime of figuration, representation, and visualisation. With Suprematism, the pictorial is finally liberated and can soar toward the infinite. Each of these stages played its role in the principal breakthrough. It was thanks to them that Malevich was able to emancipate himself. He acknowledged this even as he left them behind in order to "rise above the Earth and free himself from the rings of the horizon". Cubism had been the great step forward: "Thanks to the pulverisation of the object, The Cubists went beyond the figurative and from that point on a purely pictorial culture began. The major element in the making of the painting began to blossom in and of itself, it was no longer the object that appeared on the stage, but colour and painting themselves. Cubism signified liberation from… the surrounding creative forms of nature and technology, and paved the artist's way toward absolute, inventive, immediate creation". Futurism is given credit for its thematic

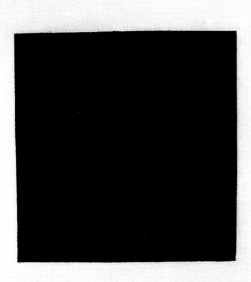

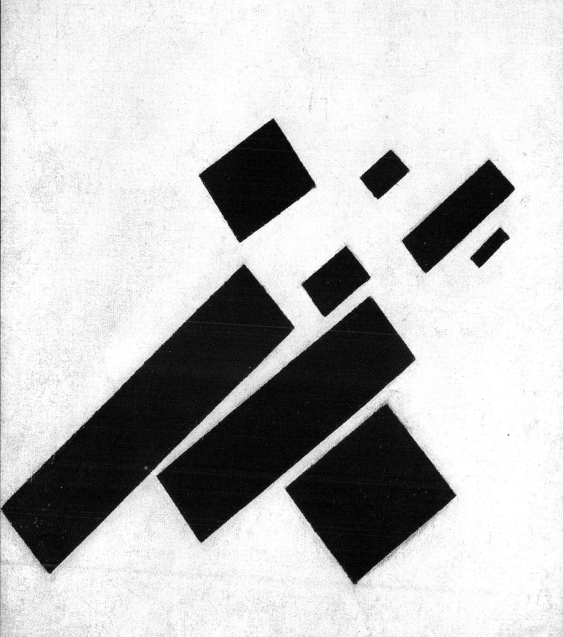

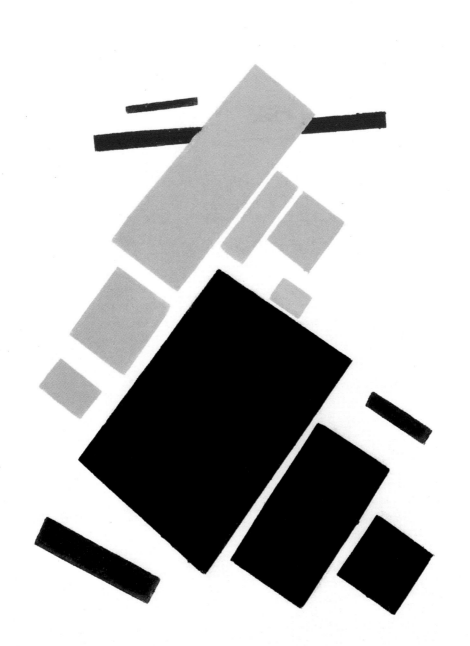

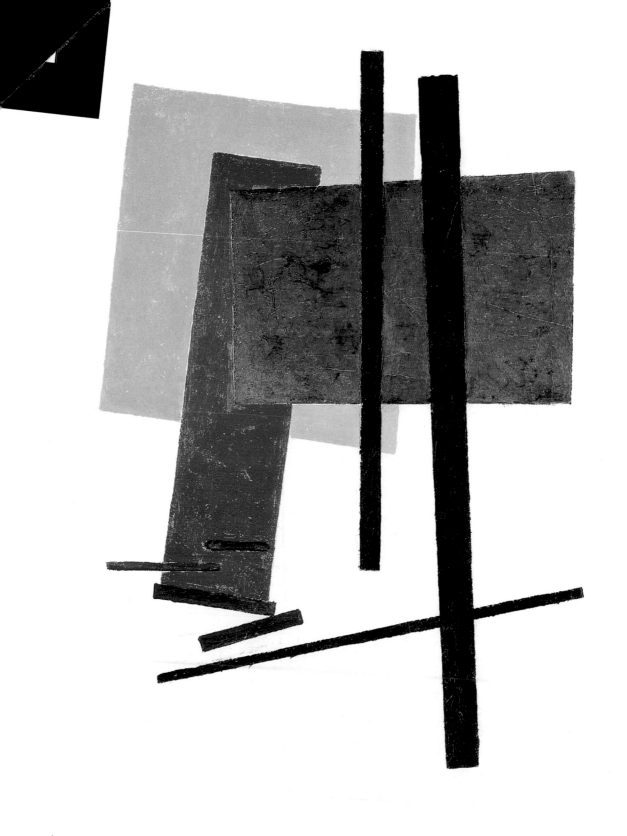

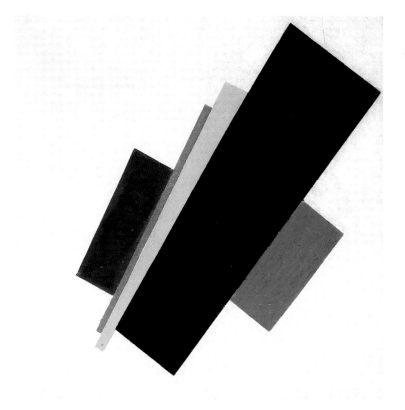

of the dynamism of the modern world, but "its efforts to obtain a pure pictorial form as such were not crowned with success: it could not escape the figurative in general, and merely destroyed objects in the name of creating dynamism". As for the enterprise of Cubo-Futurism, it had been too timid: "The Cubo-Futurists took objects as a whole, piled them up in public, and smashed them, but they did not – alas! – burn them." What Malevich now means by "pictorial realism" is "painting as its own objective". Realism should not be confused with copying or transposing the real: "There is creation only where a form appears in the painting that takes nothing from what has been created in nature, but which develops pictorial volumes without repeating or modifying the primary forms of objects in nature". And, painterly to the last, Malevich painted his *Black Square* with little Impressionist strokes rather than measuring it out and filling it with uniform colour; he wanted the work of man's hand to be visible even in the unsteady touch and inaccuracies of the sides of the quadrangle. When, in 1915, Malevich showed his first Suprematist works, he eclipsed his rival Tatlin; *Black Square* was the key work of the avant-garde. After the Revolution, the roads of these two old friends led further and further apart. Tatlin was a loyal servant of the theory of the "culture of materials", and expertly used artistic forms for purely utilitarian ends; this, indeed, is the basic procedure of Constructivist art. Tatlin was inevitably opposed to the tendency in Malevich's Suprematism to transcend the issues of colour and surface and consider only the representation of the infinite, and his *Monument to the Third International* illustrates this. Nikolai Punin has described Tatlin's position as "terrestrial [*bespredmietnik*] abstraction", making an interesting comparison with Malevich: "Each had a specific destiny. When it

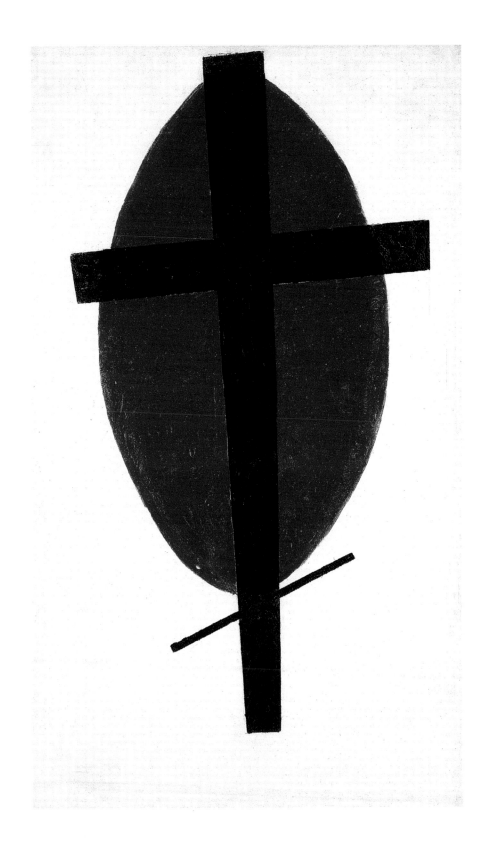

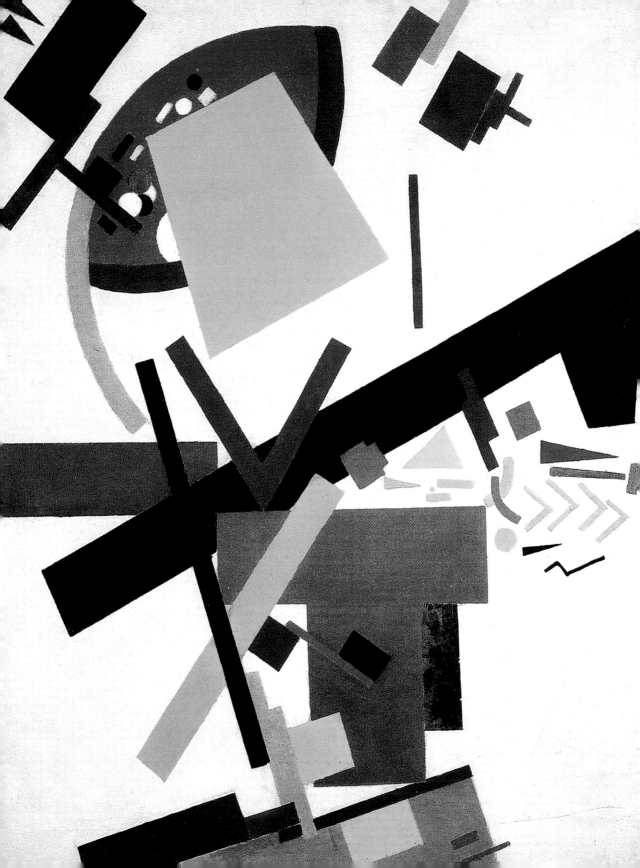

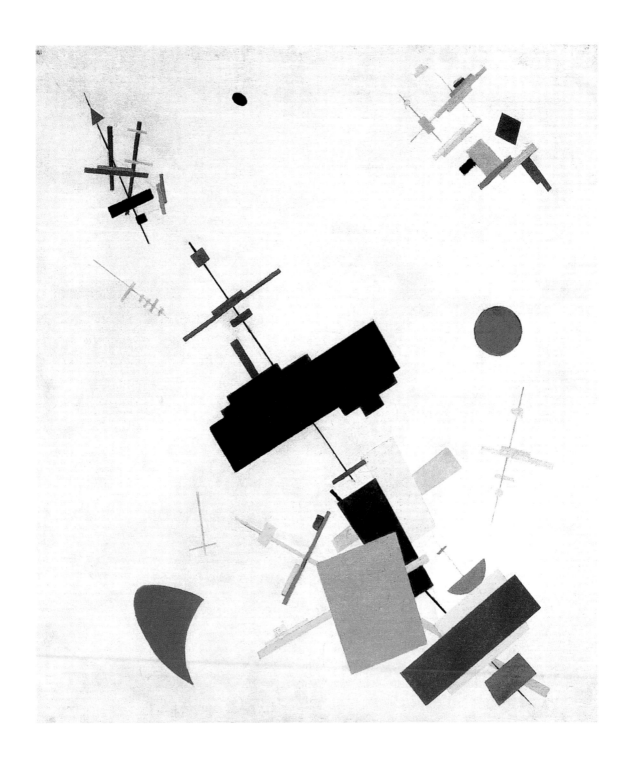

began, I don't know, but for as long as I can remember, they have always divided the world between them, establishing their own spheres of influence in Earth, sky and interplanetary space. Tatlin habitually reserved the Earth for himself, striving to push Malevich off into the sky, beyond non-figuration. Malevich did not refuse the planets, but would not cede the Earth, rightly esteeming that the Earth too is a planet, and that it too can therefore be non-figurative." Not that Malevich needed much "pushing" from Tatlin, writing to Matiushkin in 1917 "I saw myself in space, concealed in points and coloured stripes; there, in the midst of them, I depart into the abyss. This summer, I declared myself president of space."

These ideas were in the air of the time. Evgeny Kovtun tells us "The theme of overcoming gravitational attraction and of humankind launching out into the cosmos thrilled the protagonists of Russian Futurism. There can be no doubt that they were influenced in this by the philosophy of Nikolai Fiodorov, whom they greatly respected. But there were also personal conceptions of space that had taken form in the poetic and pictorial work of the Futurists, which had led them to make futurological deductions concerning humanity's adventuring out into cosmic space." In his prognostic fragment, "The Rock from the Future" (1921–22), Khlebnikov painted a picture of human life in "floating cities", in a gravity-free environment: "On the path of the absence of weight humanity walks, as if along an invisible bridge. On either side runs the ravine leading to the abyss…; a black terrestrial line indicates the path. Like a serpent floating on the sea with its head held high, the building floats in the air with its breast, like the letter *F* upside down. The building as flying serpent." Malevich, when developing the ideas of space that arose in his own art, was the first Russian artist to reach such futurological conclusions. As early as 1913, he dreamed of periods when "great cities and the studios of contemporary artists will be located aboard enormous zeppelins". His Suprematist ideas led him to believe that humanity can master not only what lies close to Earth, but cosmic space too. In his brochure "*Suprematism, 34 Drawings*", published in 1920, he argues the possibility of "interplanetary flight, and of orbital satellites (*sputniks*) that will allow man to appropriate cosmic space for himself".

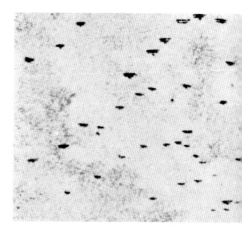

The rhythm of Malevich's ascent into the cosmos was that of the various phases of Suprematism. Thus we move from the static stage of *Black Square* (p. 48), *Red Square* (p. 49), *Suprematism with Blue Triangle and Black Rectangle* (p. 56) to the dynamic or even cosmic stage of *Eight Rectangles* (p. 58), and *Aeroplane in Flight* (p. 59). In the two later paintings, we see the square decomposed into rectangles or trapeziums, becoming a constellation of shapes that remain suspended in a single plane. *Aeroplane in Flight* comprises thirteen quadrilaterals, and bears the caption "Suprematist compositional elements"; as its title unequivocally indicates, it is not abstract, but refers to the "mythology of flight" in early 20th-century Russian art – a mythology that coincided with the actual advent of powered flight. In Malevich, the notion of vision in flight marks a vital step forward in the Suprematist consciousness and explains how objects are emancipated from their weight. Thereafter, the intersideral dust of the non-objective fourth dimension

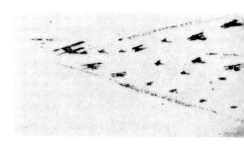

PAGE 64:
Supremus no. 56, 1916
Oil on canvas, 80.5 x 71 cm
Saint Petersburg, State Russian Museum

The "Reality" that inspires Suprematism, 1927
Photos from *The Non-Objective World*

Suprematist sky-scraper inserted into the New York skyline. Photomontage published in the Polish journal *Praesens*, 1926, no. 1

combines with the concept of spatial relativity in a pure notion of infinity, given material form in flying pictorial carpets of dazzling brilliance such as the *Suprematisms* (pp. 60–61) or *Pictorial Volumes in Movement* (p. 63); ever more complex and disintegrated, these paintings are veritable fireworks.

Supremus no. 56 (p. 64) is a sort of aerial view or plan of a town, in which we perceive the architectural forms we shall next encounter in the *Architekton* projects (pp. 66–67). These combinations of rectangular forms were used in numerous architectural projects. *The Environment of "Reality" that inspires Suprematism* (p. 65), photos published in 1927 in *Die Gegenstandlose Welt* (*The Non-Objective World*) give some idea of what Malevich was attempting to convey in *Supremus no. 56*; we see several units floating around the central unit, which crosses the canvas obliquely. Malevich observes in his *God Has Not Been Dethroned*: "Nature is concealed in the infinite and its numerous facets, and is not revealed in objects; it has, in its manifestations, neither language nor form, it is infinite and cannot be encompassed. The miracle of nature is in the fact that it resides in its entirety in a tiny seed and yet cannot be encompassed in its entirety. He who holds a seed holds the universe in his hand, and yet he cannot perceive it, for all the scientific arguments and the obviousness of the seed's origins." The painter-philosopher adds: "Man's skull is also the cosmos". In 1920, Malevich was devoting ever greater amounts of energy to architecture. He saw it as synthesising all the arts: "Architecture is a synthetic art, which is why it must unite with all other domains of art." It goes without saying that Malevich's architecture is Utopian, but his next project returned to earth, embracing technologies closer to the possibilities of the time. This was the *Architektons* (p. 66–7), a series of sculptures of extraordinary inventiveness and a multitude of applications. Based on a canon of squares divided into vertical or horizontal assemblages, the *Architektons* successfully combined aesthetics and function. They also foreshadow in visionary fashion current research on energy sources and space stations. Malevich dreamed of a "time when Earth and Moon will be a source of energy and movement for humankind, that is, of the time when it will use their rotational force as water for its mill, for currently all things turn in vain."

PAGE 67:

LEFT:
Architekton: Gota, mid–1920s
Plaster, 84.5 x 48 x 48 cm

RIGHT, AT THE TOP:
Architekton: Beta, c. 1925
Plaster, 27 x 59.5 x 99.3 cm

RIGHT, AT THE BOTTOM:
Suprematist Ornamentation, 1927
Plaster, made in collaboration with Nikolai Suetin

Here Suprematism shows its true face, and in it the world is revealed. Far from the "nihilism" of which he was accused, Malevich was in search of a new image of the world; the old image had been degraded or crushed by materialism, by the very "modernity" that Baudelaire had sought to define. The result was visionary projects and a Utopian architecture, and paintings and drawings that attempt to express the rhythms of the universe. One such is *White on White* (p. 68), which conveys the fading of forms into space and their ultimate extinction. Another is the yellow quadrilateral of *Suprematist Painting* (p. 69), which spreads out into a trapezium within a space whose parallels meet. "The white square carries within it the white world (the construction of the world) by affirming the sign of the purity of human creative life". This was the Utopia of a visionary artist. It was wholly incompatible with the grim sociological reality of the Soviet Union.

PAGE 68:
White on White [commonly referred to as the *White Square*], 1917
Oil on canvas, 78.7 x 78.7 cm
New York, Museum of Modern Art

PAGE 69:
Suprematist Painting, 1917–1918
Oil on canvas, 105 x 70.5 cm
Amsterdam, Stedelijk Museum

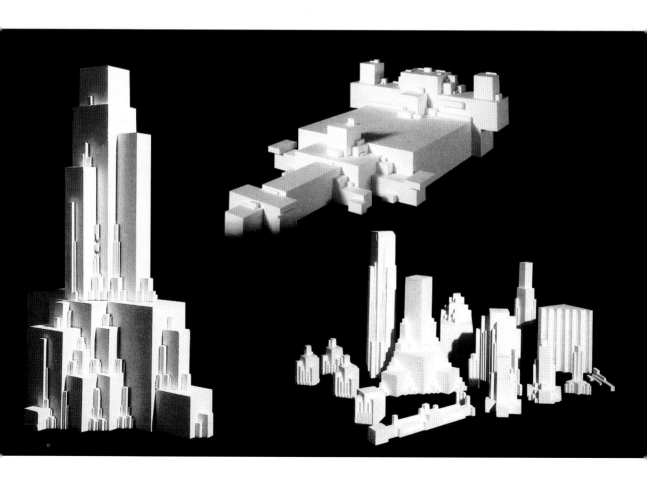

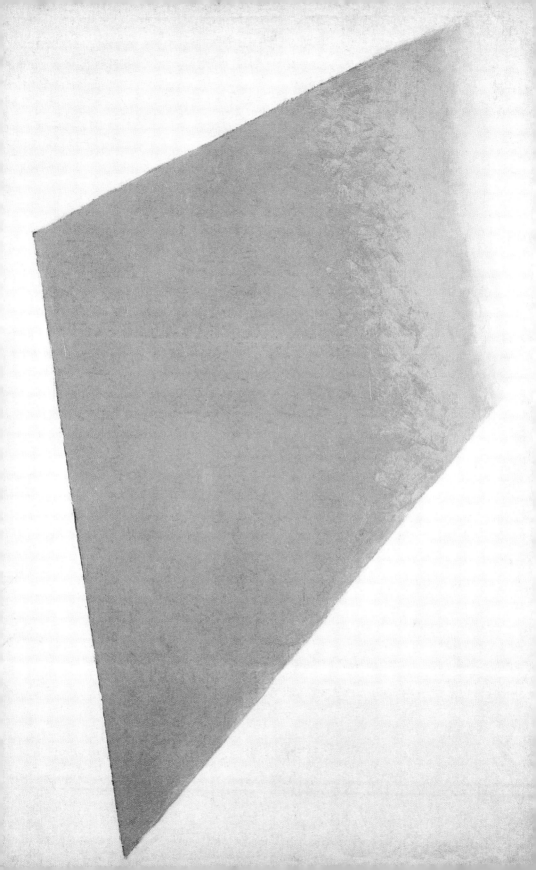

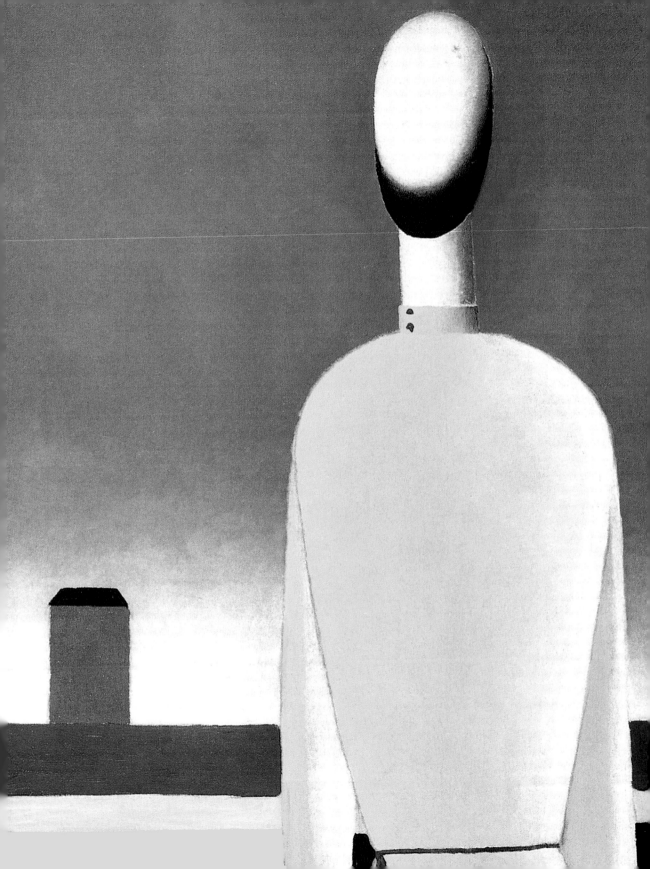

The Prospect of World's End
1927–1935

What led Malevich back to figuration? Was it a regression? Was it a cat and mouse game with the increasingly totalitarian regime? – The avant-garde was, in Stalinist eyes, infected with "bourgeois industrialist decadence". Much grave discussion has been devoted to this question. But today it is agreed that Malevich simply felt the need to go still further, and say something new in paint. True, the advent of Stalinism and the hostility of the ideologues counted for much. But with hindsight we can see that, after the final Suprematist period of *White on White* paintings, Malevich's aesthetic reflection and artistic trajectory inevitably led him to reconsider painting. This took practical form. Serge Fauchereau is close to the mark when he states that, despite the circumstances, it was primarily an aesthetic choice: "With both Malevich and Tatlin – who also returned to the easel, and, around 1930, painted rather tame nudes and still lifes – we must speak of a return to painting. The most authentic artists take care not to repeat themselves when they have exhausted a particular avenue of research. When art has been taken to a point of no return – whether it be Malevich's white on white or Duchamp's ready-mades – nothing remains to the artist but silence and inactivity. But in due course he perceives, generally after a long period of reflection, that, if he starts from the "absolute zero" to which he has brought his art, everything is again possible. Thus, during his supposed silence, Duchamp was secretly working on his last work, the large construction *Étant donnés…* Similarly, when Malevich returned to painting, it was in a very different perspective. There was no impulse to join the official socialist realist painters, whom he did not in any case frequent, when he again began painting figurative works. As Pontus Hulten has written, "the motifs of his return to figuration are at once more inward and more personal, not to say inherent in the very development of his painting". There is no progress in painting; Malevich's new manner is neither more nor less progressive."

The Association of the Painters of Revolutionary Russia, the AKhRR, an umbrella organisation for associations of artists committed to Socialist Realism, enjoyed government support. Becomingly increasingly powerful, it virulently attacked the avant-garde for exhausting the State coffers on unproductive and insufficiently accessible experiments. Under pressure from AKhRR, Malevich was sacked and the GINKhUK dissolved. To console him, he was granted the opportunity to travel in the West. In early March 1927, Malevich's welcome in Poland had overtones of a Roman triumph. Exhibitions, banquets and meetings with the prominent came one after another. The Poles celebrated the return of "their" prodigal son; he spoke Polish and his Suprematism had preceded him. Malevich took the opportunity to publish in *Zwrotnika* an article hostile to

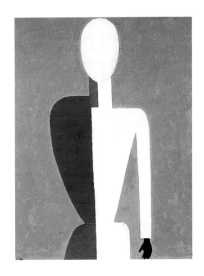

Torso (Prototype of a New Image), 1928–1932
Oil on canvas, 46 x 37 cm
Saint Petersburg, State Russian Museum

AT THE TOP:
Four Figures with Hammer and Sickle,
c. 1930–1932
Pen and ink on paper, 7.6 x 12 cm
Paris, Musée national d'Art moderne –
Centre Pompidou

PAGE 70:
Complex Presentiment (Torso with Yellow Shirt), c. 1930
Oil on canvas, 99 x 79 cm
Saint Petersburg, State Russian Museum
Inscribed on the back: "The composition has been made from elements, from the sensations of emptiness, solitude and lack of ways forward in life 1913. Kuntsevo."

Constructivism and its emphasis on functional art: "The true artist never examines objects from the point of view of their utility; on the contrary, all utilitarian values will be subordinated to the forms that derive from formal laws. Constructivism, for example, is a tendency advanced by former painters, artists who now recognise only utilitarian values and have eliminated art as useless." In late March he went on to Berlin, and was welcomed to the Bauhaus by Walter Gropius, Mies van der Rohe, Hannes Meyer, László Moholy-Nagy and Wassily Kandinsky. A series of lectures and exhibitions followed, and Moholy-Nagy, won over to Suprematist ideas by El Lissitzky, saw to the publication by the Bauhaus of Malevich's writings, under the title *Die Gegenstandlose Welt* (*The Non-Objective World*).

But this was a short recreation. Malevich soon afterwards had to return to the Soviet Union. At this point, a major event occurred that had two important effects on the future of Malevich's *œuvre*. Anxious about what awaited him in Moscow, Malevich prudently left behind everything he had brought with him:

Winter Landscape, c. 1930, antedated to 1909
Oil on canvas, 48.5 x 54 cm
Cologne, Museum Ludwig
Note the yellow square smuggled into the picture in the form of the house on the left.

Flower Girl, late 1920s, antedated to 1903
Oil on canvas, 80 x 100 cm
Saint Petersburg, State Russian Museum

paintings, graphic works, the *Architektons*, several notebooks of his writings and explanatory plates intended to help the public understand his work. These he confided to the tender care of the architect Hugo Häring. He never saw these works again. They were stored in Germany, and thanks to Häring, survived the Second World War. This precious hoard was discovered and bought in 1951 by the Stedelijk Museum of Amsterdam; the only elements not so bought were those that had already been purchased by the New York Museum of Modern Art in 1936, during the exhibition *Cubism and Abstract Art*. The Soviet Union subsequently buried in its museum cellars all trace of the works of its avant-garde, and those of Malevich in particular, though, unlike Nazi Germany, it did at least not burn such works. Consequently the Häring "collection" was – till the fall of the Berlin Wall – the only source of information about Malevich's work available to the West. The second effect was this: on his return, anxious to reconstitute the major steps in his development, and to reproduce the essential works that he had left in Germany, Malevich painted "improved" copies of them. They were "improved" in the sense that they carried traces of his later discoveries. Malevich antedated these works, causing a formidable imbroglio. He used them to complete the 1929 retrospective of his work held in Moscow's Tretyakov Gallery (official hostility toward Suprematism was not yet unanimous).

Women Harvesting, c. 1930
Oil on wood, 71 x 103.2 cm
Saint Petersburg, State Russian Museum

PAGE 75:
Head of a Peasant, c. 1930
Oil on plywood, 71.7 x 53.6 cm
Saint Petersburg, State Russian Museum
It is hard to avoid the comparison with Van
Gogh's *Wheatfield with Flight of Crows*. The
aeroplanes have become the ill-omened birds,
and the peasant is like a Christ-figure.

Malevich placed his return to painting at the service of the Russian peasantry, whom he wished to defend against the brutal mechanisation and collectivisation now in process. Expropriated *kulaks* were savagely brought to heel and deported or massacred if they resisted the five-year plan. In Malevich's work, canvas by canvas, we witness the gradual disintegration of the peasant world under the devastating influence of collectivisation. In his Futurist years, Mayakovsky had sported a peasant smock for its shock-value. Now Malevich painted a man in a yellow smock standing close to a windowless house in a blank landscape. The painting bears the premonitory title *Complex Presentiment. Torso with Yellow Shirt* (p. 70), and embodies the early stages of this disintegration. The man has already lost his face. He was soon to lose his beard and his arms. Malevich's "presentiments" were increasingly tragic. He had not painted a face, Malevich said, because "he could not see the future man", or because "the future of man is an insoluble enigma". The Socialist Realist painters were by now beginning to eulogise the workers on the *kolkhozs* (collective farms), depicting them hammer or sickle in hand. Malevich alone among Russian painters referred to the ferocious oppression of forced collectivisation. Under his brush, mankind soon came to be represented by mutilated tailor's dummies: the prisoners of the *gulag*.

It seems that Malevich's initial goal was only to replace the missing links in the chronology of his work. For example, in the late 20s, he painted a *Flower Girl* (p. 73), dating the work to 1907, and in 1930, *Woman Harvesting* (p. 74). These works are far too beautiful to be genuine juvenilia, and far too geometrical and

Young Girls in the Fields, 1928–1932
Oil on plywood, 71.3 x 44.2 cm
Saint Petersburg, State Russian Museum

Cubist to be innocent works of Impressionism. Suprematism is cited in the choice of red for the *Flower Girls*'s dress. As to Malevich's square, it is smuggled in everywhere in the form of windowless houses. One such is the orange-yellow wall of the little house in *Winter Landscape* (p. 72), a work painted around 1930 but dated 1909; the superlative colours are Fauvist, and the tubular, stylised trees Cubo-Futurist. We should therefore speak of Post-Suprematism rather than Neo-Impressionism; when Malevich revisits Cubo-Futurist motifs in works like *Young Girls in the Fields* (p. 76) and *Sportsmen* (p. 77), the structures in which he accommodates them are clearly informed by Suprematism.

But after a while, Malevich lost interest in plugging chronological lacunae, and began a new period in his development. His peasants increasingly took on a metallic, robotic aspect, rather like his "convex" figures of 1912. This was the late 20s, and he was careful to explain his intentions: "The painting and the pictorial culture of the provinces attack the metallic culture of the town; they accuse it of being incomprehensible to the masses. Whereas the ploughshare is comprehensible to every peasant and indeed to every child, the electric plough is incom-

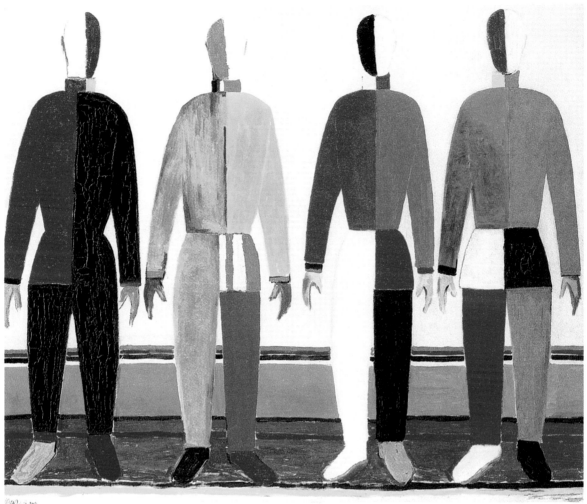

Sportsmen, 1928–1932
Oil on canvas, 126 x 164 cm
Saint Petersburg, State Russian Museum

prehensible to the countryside as a whole. For this reason, painting says: 'We must make things that can be understood by the masses'. The peasant would say: 'We must create a plough that someone will understand'." Malevich carved and painted his protagonists like ploughshares in order to make them comprehensible.

Thus the *Head of a Peasant* (p. 75) is divided into four Suprematist forms, including the two quadrilaterals of the beard, which might indeed be ploughshares. But it is also an icon, a portrait which might be that of a peasant Christ. With the perfect symmetry of his slanting eyes and inexpressive face, he restores a visible configuration without betraying the "non-objective world". But the image's power so exceeds its subject that it seems necessarily symbolic. Knowing the socio-historical context and Malevich's intentions, we might interpret the peasant as a hero who stands up against the mechanisation and collectivisation that threatened the peasants in the background, whom he seems to protect. Planes advance through the sky, like the ominous birds in Van Gogh's *Cornfield with Crows*, machines of domination and predation come to destroy the peas-

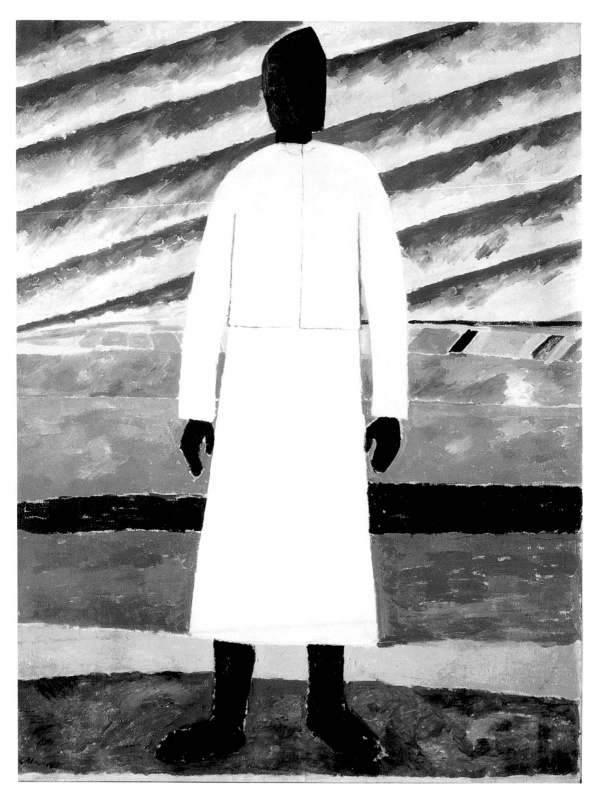

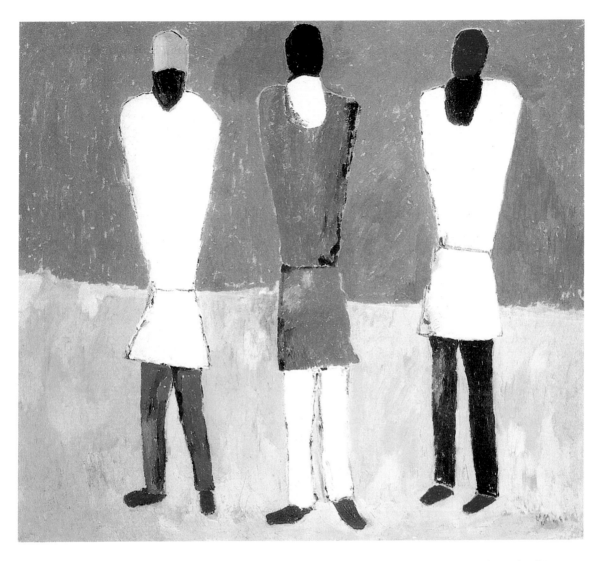

Peasants, c. 1930
Oil on canvas, 77.5 x 88 cm
Saint Petersburg, State Russian Museum

PAGE 78:
Peasant Woman, c. 1930
Oil on canvas, 126 x 106 cm
Saint Petersburg, State Russian Museum

ants' traditional culture. Malevich's work, increasingly complex and ambiguous beneath its austere appearances, lends itself to the most various intepretations. He sets before us the gradual enslavement and mutilation of the peasant world, in which we see his figures lose first their facial organs, then their beards (that is, for Orthodox Russians, their dignity) and finally their arms. But certain critics have perceived in these figures robots or dummies reminiscent of Futurism or of the Metaphysical paintings of De Chirico or Savinio. So rich in possible meanings is the faceless man, and so common to this period, that others have spoken of a Surrealism like that of Magritte or Max Ernst. The most negative critics have seen in Malevich's entire "return to painting" a submission to official painting and a concession to the pressures that he faced. This suggests a very superficial understanding of Malevich's *samdorok* nature, while he himself spoke of "symbolism". In 1931, he made a seeming confession to the Ukrainian painter Lev Kramarenko: "I am thinking of returning to painting in order to paint symbolic pictures. I want to create an image that works."

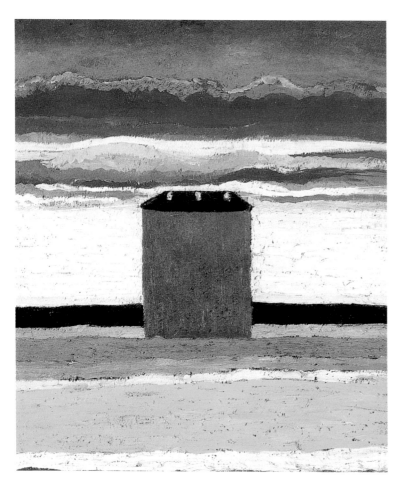

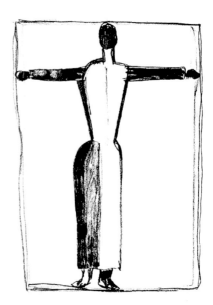

One thing is certain. "Symbolic" or not, these images raise many questions and interpretative issues, and the passage of time, combined with a better understanding of Malevich and his work has allowed us to solve many of them. There is a general consensus that the colours and formal beauty of these works are extraordinary, even where critics differ in the meanings that they ascribe to them. Are these the products of realism, Surrealism, or of humanism in the service of social protest? It should not be forgotten that Malevich remained viscerally anti-Constructivist. He had long denounced the perverse effects of Constructivist ideology placed at the service of the state, that is, of Utopian perspectives requiring that humanity master nature by means of progress and technology. For Malevich, humanity *is* nature, and cannot therefore conquer it. Marcadé explains: "The new Nature that Malevich announces in his post-Suprematist pictures again takes the incarnate form of the peasant world, which Constructivist ideology tended to condemn as reactionary. Here Malevich seems to coincide with the lay Christian thinker Nicolai Fiodorov, who believed that the invasion of the countryside by the town – a tendency accelerated by unbridled capitalism – had to be reversed, and that the country should prevail over the town. Of course, his defence of the countryside was not intended to defend a specific socio-political situation or social class. The countryside was the place

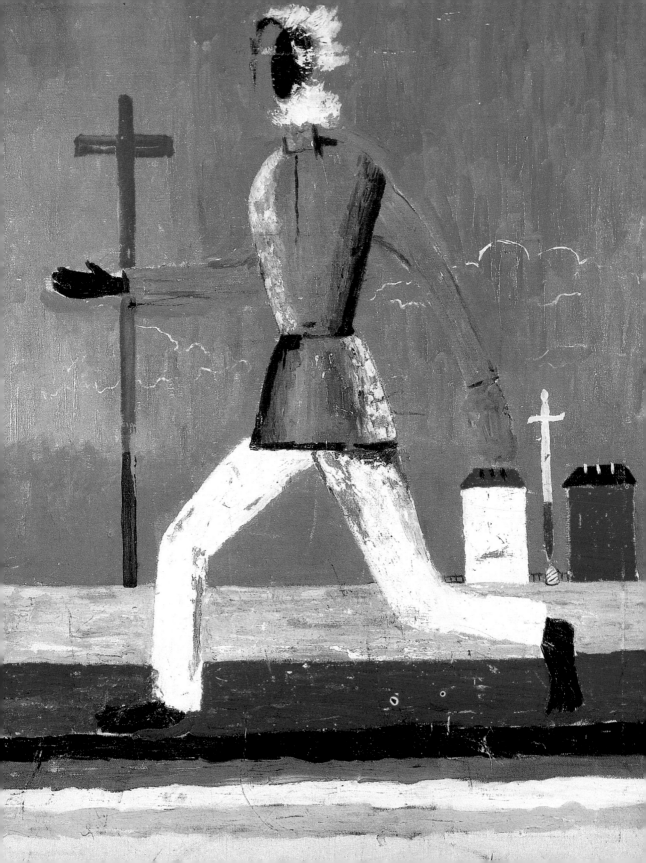

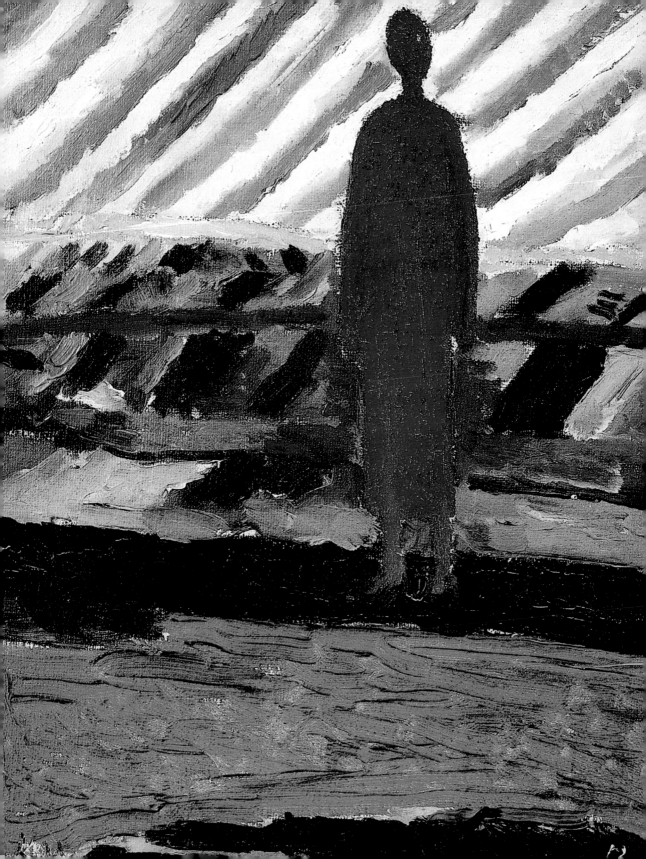

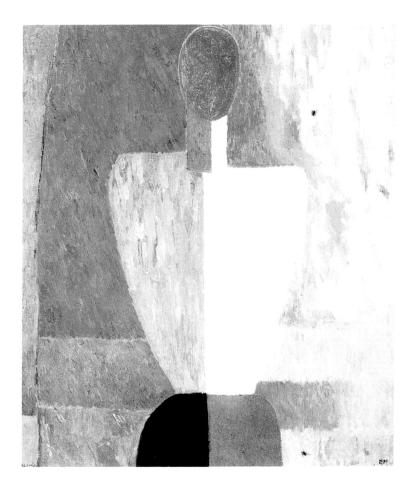

where nature as *physis* - birthplace of the object-free world and the eternal body – was best manifested. Malevich's return to figuration and the world of nature seems to have occurred after he had recharged his batteries in his native Ukraine. It can be seen from the above he had nothing in common with the "Boichukists", the followers of Mikhailo Boichuk, who painted collective farmers dressed up as figures from icons. Malevich hit out at the Boichukists in his Ukrainian almanach *Avant-Garde* (1930), in an essay entitled "Architecture, Easel Painting and Sculpture": "The artists who took… the path of monumental painting… take themselves off to the world of the ancient catacombs… clothing our modernity in the forms of monastic monumental painting… Ignoring the avenues of modern painting of the 20th century, these artists head off to the 15th century." Monumental, brilliant-coloured, hieratic, and static, Malevich's figures had by now become archetypes of icon painting. The *Head of a Peasant* refers to the Orthodox representation of the "Holy Face": Christ *Acheiropoietos*, literally, "made without human hands", by divine intervention. "Each painting of this cycle," writes Evgeny Kovtun, "gives an impression of solemnity, monumentality and gravity in the face of events, though there is no activity. It seems that the black-faced *Peasant Woman* (p. 78) and other protagonists of the peasant cycle have become organic and constitutive parts of Malevich's Suprematist universe, which was previously uninhabited. Created after Suprematism, certain works of

Portrait of a Woman, early 1930s
Oil on plywood, 58 x 49 cm
Saint Petersburg, State Russian Museum
Inscribed on the back: "K. Malevich Malewicz.
1909 motif [date corrected to 1919]".

Standing Figure, c. 1930
Black crayon on paper, 35.5 x 22 cm
Amsterdam, Stedelijk Museum

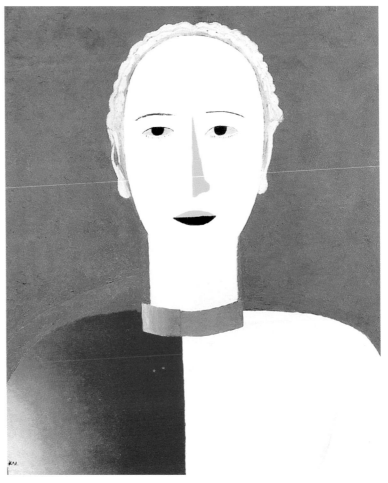

the cycle (*Young Girls in the Field*, p. 76, and *Sportsmen*, p. 77) retain the cosmic quality so powerfully expressed in the artist's non-figurative paintings."

Faces without faces, faces that have lost their beards, dummies without arms, stigmatised or crucified beings: Malevich's icons show humanity to be the victim of some nihilistic apocalyptic devastation. They are as if frozen in expectation of world's end. The spectacle ends in darkness. The sun has not merely been conquered, it has disappeared… "It is not for nothing that Orthodox icons of The God of Sabbath, Jesus Christ, the Prophets, the Apostles and all the Fathers of the Church are represented with a beard", Marcadé points out. "For the religious consciousness of Orthodoxy, a beardless Christ would have an effect like that produced in persons of Western culture if the Apollo Belvedere grew a large Victorian-style beard." To remove a man's beard was to remove his dignity. To remove his arms – see the three *Peasants* (p. 79) – is to bind him, remove all his scope for action, put him in a strait-jacket. The *Man Who Runs* (p. 81) does so blindly as if flayed alive between the bloodstained sword of power and the cross of suffering; the base of the cross, like his face and hand, is blackened as if rotten. We see him frozen in mid-stride, fleeing for all he is worth.

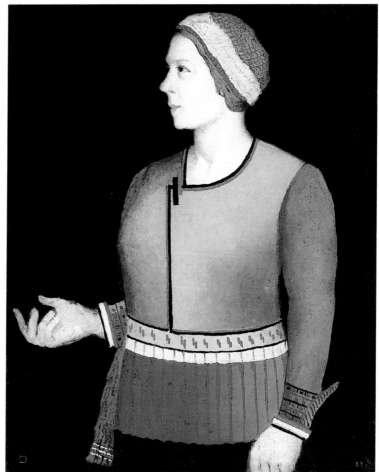

Hope, however, springs eternal, and after this period of suffering and revolt, came one of optimism. Malevich's experience now contained many contradictory elements. On the one hand, he was granted a retrospective at the very official Tretyakov Gallery, and even commissioned to paint a mural at the Leningrad Red Theatre. At the same time, he was arrested and detained for questioning, remaining in custody for a fortnight under suspicion of propagating subversive ideas. As Serge Fauchereau notes, the Stalinist regime was growing increasingly oppressive, and seven or eight years later Malevich would not have escaped so lightly; he would probably have been sent to the *gulag* or shot. In 1932, he was entrusted with a laboratory at the Russian State Museum, a post he retained till his death. Several dozen of his works, including the seditious *Faces without Faces*, appeared in official exhibitions such as *Fifteen Years of Soviet Art* (November 1932–May 1933). The regime nonetheless considered his art obsolete, a stepping stone on which the large flat feet of Socialist Realism were now placed, as it rose to favour with the slogan "Backwards to realism, forward toward the masses".

Malevich's humour is a constant in his life and work; it was a match for all the vicissitudes of his life. Neither Picasso nor Léger made any bones about

Maternity, c. 1930
Pencil on paper
Whereabouts unknown

PAGE 87:
Woman Worker, 1933
Oil on canvas, 71.2 x 59.8 cm
Saint Petersburg, State Russian Museum
The Virgin has become a worker and her son has
disappeared. Only her hands retain the imprint
of his form.

Mother of God "Hodighitria",
Novgorod school icon, 15th century
Former Morozov Collection

moving from Abstraction to forms of realism and back. But Malevich did not,
in his last years, turn to "real" portraiture because of the *diktats* of the State.
Socialist Realism had become obligatory, and Tatlin and Rodchenko conformed.
Not Malevich; his portraits can seem conventional, but in fact they followed
the painter's own inward logic. They were inspired not by the heroes of Russian
industry, but by the painters of the Renaissance. They were clothed in extraordi-
nary Suprematist garments of intensely vivid colours, they retained a discreet
tendency toward geometrisation, and were studded with signs that the commis-
sars would never detect and the initiate could never miss. And, in a piece of defi-
ant coquetry, they were signed with a little black square. The astonishing *Young
Girl with a Comb in her Hair* (p. 2) is only ostensibly realist. In other respects,
she more closely resembles the heroine of the then-fashionable science-fiction
film *Aelita* (1924). And, despite the title, which was no doubt invented by some
museum bureaucrat, there is no "comb" to be seen; what we see is Suprematist
forms inserted into her skull like the builder's saw in the *Perfected Portrait of
Ivan Vasilievich Klyun* (p. 24). In short, Malevich was now portraying the face of
the new man and new woman of the future. They are emblematic figures, their
eyes wide open and, as in icon paintings, looking out through the visible to the
true reality, which in this case is perhaps associated with a better future. Male-
vich dubbed the style of this, his last period, "Supranaturalism". The timeless
beings that he represents belong to another world, a future world from which

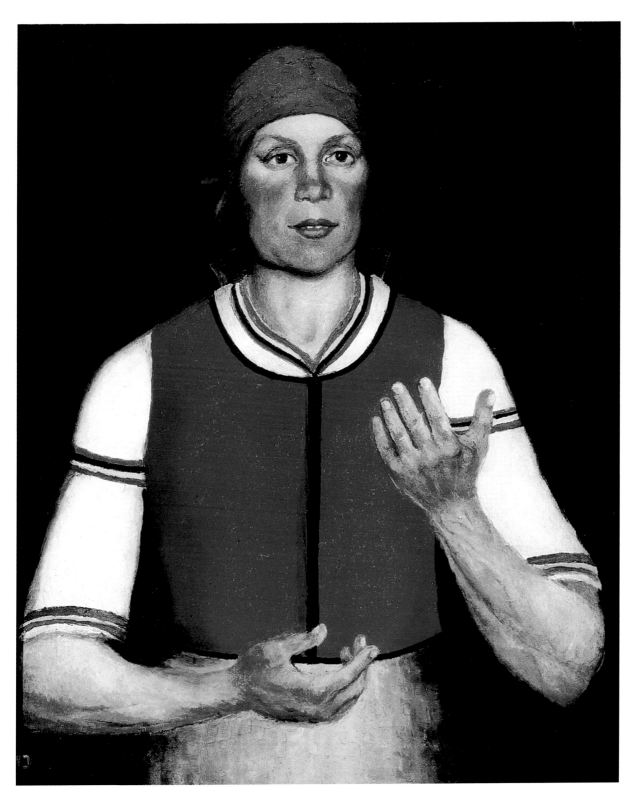

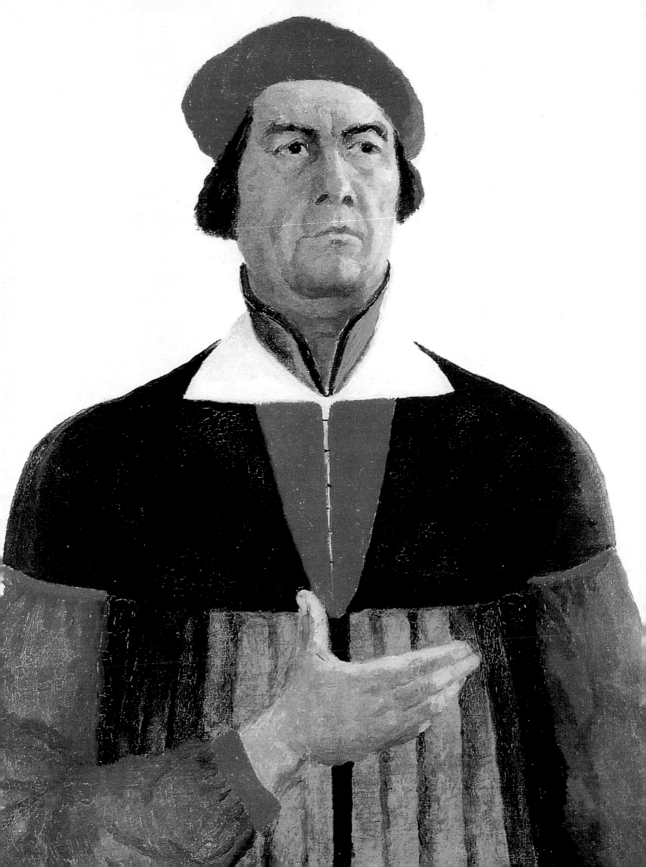

Big Brother has been banished, and they seem to communicate with coded gestures that they alone understand. The *Woman Worker* (p. 87) is one of these hieratic figures. She too wears the astounding clothes that Malevich invented for the future society in which he perceived her. The painting is effectively a maternity from which the child has been omitted; it is implied by a gesture like that of *Hodighitria* (p. 86). There are Messianic overtones to this child expected but as yet unborn. These figures might be members of some new religion, transmitted to us by Malevich in a last message of artistic love and solidarity. Above all, there is the *Self Portrait* (p. 88), which shows him in the Renaissance garb of a Reformer, indicating with a gesture expressive of the grave humour that pervades his entire *œuvre*, that he is there to show us the way forward. The generously open hand sketches the outline of the absent square, signalling all that Malevich knew that he had brought to the history of painting. And he leaves us with the message that the entire life of a man can thus be reduced to a single gesture.

Three Heads, post–1930
Pencil on paper, 22 x 35.2 cm
Saint Petersburg, Private collection

PAGE 88:
Self Portrait, 1933
Oil on canvas, 70 x 66 cm
Saint Petersburg, State Russian Museum
Inscribed on the back: "K. Malewicz 1933. Saint Petersburg 'The Artist (black square)'". In a final challenge to the Stalinist regime, the black square is hidden, but the artist's hand indicates the form as in hope.

MALEVICH
1878–1935

"When the habit and consciousness of seeing in pictures representations of little corners of nature, of Madonnas and lubricious Venuses has vanished, then and only then *shall we see the pictorial work…*"

Kazimir Malevich:
0.10 (tract, 1915)

Malevich and his daughter Una, photo from the early 1920s

PAGE 90: The UNOVIS Group (Proponents of the New in Art) at Vitebsk station in 1920. In the centre, Malevich holding a round plate with black circle and square. To his left, diagonally above, Vera Ermolaeva and Evgenya Magarill by his left arm, Chashnik below his extended right arm, Nina Kogan (wearing a hat) and El Lissitzky (in woollen hat). Standing, below centre: Lazar Khidekel.

Chronology

1878 Kazimir Severinovich Malevich born in the Ukraine on 11 February 1878 to parents of Polish origin. His father works in various sugar refineries. Faced with the choice of factory or countryside, Malevich opts for painting.

1896 His family moves to Kursk. Malevich meets the naturalist painters known as "the Wanderers", and takes up painting in dilettantish fashion. Saves for his move to Moscow by working as technical draughtsman for the Kursk-Moscow railway.

1901 Marries a Polish woman, Kazimira Zgleits.

1904 Arrives in Moscow, where he hopes to enter the Academy of Painting, Sculpture and Architecture. That year, the collector Shchukin acquires his first Matisse.

1905 Under Monet's inspiration, works *en plein air* at Kursk in Impressionist style. Takes part in the December revolution on the Moscow barricades. Mutiny of the battleship *Potemkin*.

1906 Studies in the studio of F. I. Roehrberg with other Ukrainian artists. Death of Cézanne.

1907 Exhibits for the first time at the "Moscow Society of Artists", with Burlyuk, Larionov, Goncharova, Kandinsky and others.

1908 Shows his *Three Studies for a Fresco* at the Moscow Society of Artists. Trotsky, in his Austrian exile, founds the newspaper *Pravda* (*Truth*). Survage and Archipenko move to Paris.

1909 At the second *Golden Fleece* exhibition, discovers not merely the Fauves but Braque's *Large Nude*, the first Cubist work to enter Russia. Second marriage, to Sofia Rafalovich, the daughter of a psychiatrist. Lipchitz and Zadkine move to Paris.

1910 Takes part in the first exhibition of Russian primitivists and followers of Cézanne, *The Knave of Diamonds*, in Moscow. First abstract watercolour by Kandinsky.

1911 Beginning of his Neo-Primitivist period. Exhibits at the *First Moscovite Salon*. Matisse visits Moscow to supervise the installation of *Dance* and *Music* at Shchukin's house. In Munich, Franz Marc and Kandinsky found Der Blaue Reiter. Kandinsky publishes *Concerning the Spiritual in Art*.

1912 Larionov and Goncharov break away from *The Knave of Hearts*, which is too Western for their taste; they found the *Donkey's Tail*, at which Malevich exhibits. Larionov publishes the *Rayonist Manifesto*. First Futurist manifesto: *A Slap for Public Taste*. Malevich distances himself from Larionov and grows closer to the Futurists, declaring himself a Cubo-Futurist. Makes friends with Matiushkin.

1913 Becomes a member of the artist's association *Union of Youth*, with Burlyuk, Tatlin and others. This is the period of the *Knifegrinder*. Spends the summer in Uusikirkko, Finland, in Matiushkin's house, with Khruchenyk. The threesome publish a Futurist manifesto and compose

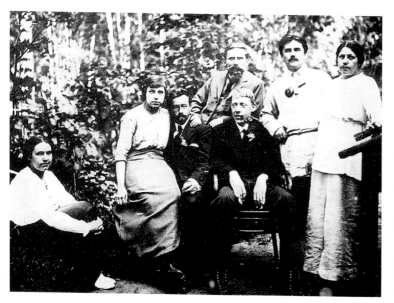

At the Malevich *dacha*, at Nemchinovka, near Moscow, c. 1915. Centre, with pipe: Vladimir Tatlin. Behind him, Ivan Klyun, on the right, Malevich and his second wife Sofia Rafalovich.

the opera *Victory over the Sun*, which is presented late that year at Saint Petersburg's Luna Park theatre. First "transmental" and "Alogist" works. Gleizes and Metzinger publish *On Cubism*.

1914 Takes part in the 4th *Knave of Diamonds* exhibition in Moscow. In the Paris Salon des Indépendants exhibits three pictures: *Samovar*, *Perfected Portrait of Ivan Vasilievich Klyun*, and *Morning After the Storm*. Larionov wants Marinetti, the leader of the Italian Futurists now visiting Moscow, to be greeted with rotten eggs. Malevich instead wears a peasant wooden spoon in his lapel. After the declaration of war, on 1 August, he draws *luboks*, propaganda posters probably worded by Mayakovsky.

1915 At the *First Futurist Exhibition: Tramway V*, organised in Saint Petersburg by Ivan Puni and his wife Xenya Boguslavskaya, exhibits a selection of Neo-Primitivist and Alogist paintings, including *An Englishman in Moscow*. During the summer, conceives of Suprematism and shows 39 examples, including the notorious *Black Square* or *Quadrangle*, which astounds public and critics alike, at the *Last Futurist Exhibition, O.10* in Saint Petersburg. Publishes *From Cubism to Suprematism: the New Pictorial Realism*. Larionov and Goncharova leave Russia for Paris.

1917 The October Revolution: the Soviets take power. The Tsar abdicates and Lenin returns from exile. The commissars of the October Revolution nominate Malevich to manage the national collections in the Kremlin. Mondrian founds Neo-Plasticism and the revue *De Stijl* with Van Doesburg.

1918 Germany surrenders. Tsar Nicholas II and his family are executed. Malevich writes articles for *Anarchy* and manages a Free Studio (SVOMAS) in Petrograd. Paints stage-sets for Mayakovsky's *Mystery Bouffe*. Grief-stricken at the death of Olga Rozanova.

1919 Exhibits his *White on White* canvases at the 10th National Exhibition. Rodchenko responds with a *Black on Black* series. Invited by Vera Ermolaeva and El Lissitzky to teach at the Vitebsk School of Fine Arts, in Bielorussia; its director is Chagall,

Photograph of Suetin, Malevich and Chashnik, Petrograd, 1923

soon to be sacked. Gropius founds the Bauhaus.

1920 Creation of UNOVIS (Affirmation of New Art) in Vitebsk, whose goal is to extend Suprematism to collective creation. His daughter Una born on 20 April.

1924 Malevich transforms the Museum of Artistic Culture into the National Institute of Artistic Culture (Ghinkouk), comprising five sections: Formal-Theoretic (Malevich), Organic Culture (Matiushkin), Material Culture (Tatlin), Experimental (Mansurov) and Methodology (Filonov). At the 14th Venice Biennale, some *Planits*, a *Square*, a *Circle* and two black *Crosses* are shown. Death of Lenin, formation of a *troika* comprising Stalin, Zinoviev and Kamenev.

1925 Works on his *Architektons* with Chashnik and Suetin. Marries Natalia Andreyevna Manchenko. Tatlin deserts the GINKhUK for the VKhUTEMAS studios in Moscow. Einstein films *The Battleship Potemkin*.

Malevich in Russian peasant smock at his *dacha*, late 1920s

1926 Both the authorities and the conservative artists of AKhRR attack the work of the GINKhUK; Malevich is sacked and the Institute abolished.

1927 Nevertheless, Malevich has some friends. The Commissar for Public Education, Lunacharsky, makes him representative of the Leningrad Institute of Artistic Culture in Germany. Malevich hopes to reach Paris. He leaves with a great many works, and spends March in Poland, where he is received as a prodigal son. On 7 April, he is received by the Dressau Bauhaus, whose director is Walter Gropius. Moholy-Nagy convinces the Bauhaus to publish a translation of Malevich's theoretical writings:

The Non-Objective World. In his absence, he is severely criticised in Russia. Does he return in order to defend himself, or is he simply "recalled"? Returns to Leningrad, to his research at the Institute for the History of Art and the construction of the *Architektons* with Suetin and Chashnik. As a precaution, however, leaves his works and writings in the care of Hugo Häring in the West. Not attracted by the prospect of exile.

1929 Forced out of the National Institute for the History of Art, he is allowed to work two weeks in every month at the Kiev Art Institute. In late November, at his "retrospective" at the Tretyakov Gallery in Moscow,

he exhibits his Post-Suprematist works, executed after his return to Berlin and antedated; he has repainted a number of works left in Germany and "improved" certain unfinished works. Trotsky is expelled from the Soviet Union. Stalin becomes the absolute master of the Soviet Communist Party and the Soviet Union.

1930 Detained for questioning for a fortnight. His friends destroy part of his archives as a precaution.

1931 In complete contrast, commissioned to restructure the Red Theatre (formerly the House of the People) in Leningrad. To transform this Jugendstil building, he uses polychrome lighting effects.

Malevich bedridden, c. 1934

Leningrad bears the expense of his funeral. The Russian Museum inherits most of his studio, in return for a pension paid to his family. Exhibited on his deathbed with the black icon on a white background above him, and surrounded by works from his different periods, he is placed in a Suprematist coffin made by Suetin, then cremated. His ashes are sent by train to Moscow, and from there to Nemchinovka, where they are buried near his *dacha*. Suetin places a white cube decorated with a black square on his tomb.

1932 The Russian Museum in Leningrad grants him a research laboratory, a post he retains till his death. A *diktat* requires all artistic groups to join a single Union, in which avantgarde tendencies are suffocated. Yet Malevich's work (his *Architektons* and recent paintings of faceless people) feature in *Fifteen Years of Soviet Art*, shown in Moscow and Leningrad.

1934 Suffering from terminal cancer, surrounded by friends and disciples, Malevich can no longer paint. His old friend Matiushkin has just died.

1935 Five of his last portraits are shown at the *First Exhibition* in Leningrad. Thereafter, none of his works is shown in the USSR till 1962. 15 May: dies in his home. The city of

Malevich on his deathbed. On the left, on end, the Suprematist coffin with black circle and square, painted by Nikolai Suetin.

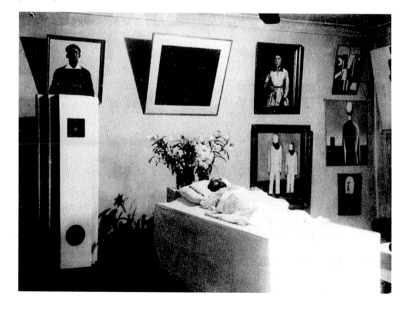

PAGE 95:
Malevich's tomb at Nemchinovka, decorated with the black square, after the burial. His third wife, Natalia Manchenko, stands by the oak on which a panel identifies the dead man.

ACKNOWLEDGEMENTS:

The author would like to offer special thanks to Jean-Claude Marcadé, renowned specialist in the Russian avant-garde, *Agrégé*, and *Directeur de recherche* at the C. N. R. S. Gilles Néret had the honour of publishing (Nouvelle Éditions Françaises, 1990) Marcadé's revolutionary work, with its new chronology and properly informed interpretation of works previously presented in partial and obscure fashion. Jean-Claude Marcadé's invaluable research supplied the basis of the present work.

The author and publisher would also like to express their profound gratitude to all those who have shared with us their passion for Malevich and their knowledge of his work. Particular thanks to the Stedelijk Museum of Amsterdam; the Costakis Collection in Athens; Aurora in Saint Petersburg; Sotheby's in London; and to all those who preferred to remain anonymous.

Devil, 1914.
Lithograph for the cover of *Sport in Hell*, a poem by Khruchenyk and Khlebnikov